POSTCARD HISTORY SERIES

Carmel

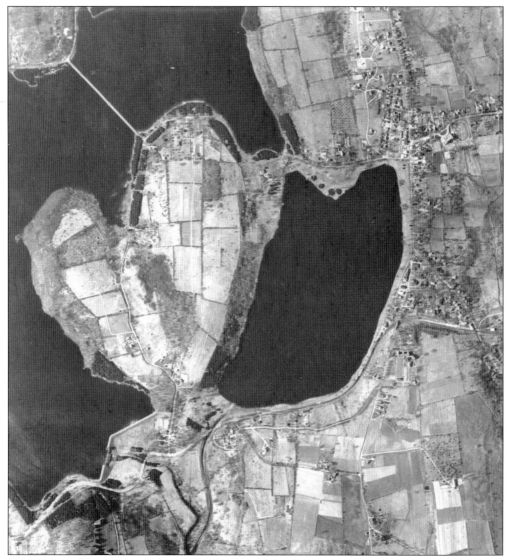

A view from above shows the agricultural town of Carmel and Lake Gleneida in 1933. The other water is the West Branch Reservoir. Note the racetrack on the upper right.

POSTCARD HISTORY SERIES

Carmel

George Carroll Whipple III

ARCADIA
PUBLISHING

Published by Arcadia Publishing
Charleston SC, Chicago IL, Portsmouth NH, San Francisco CA

Printed in the United States of America

Library of Congress Catalog Card Number: 2007920586

For all general information contact Arcadia Publishing at:
Telephone 843-853-2070
Fax 843-853-0044
E-mail sales@arcadiapublishing.com
For customer service and orders:
Toll-Free 1-888-313-2665

Visit us on the Internet at www.arcadiapublishing.com

To my grandparents Robert S. and Marie E. Feeley, who came over the hills from Greenwich, Connecticut, to establish a country house in Putnam County; my father, George Carroll Whipple Jr., who loved the county and family seat; my mother, JoeAnn Feeley Whipple, who has taught me everything of value that I know; and my late dog Jackie Ruckles, who loved to swim (illegally) in Lake Gleneida.

CONTENTS

ACKNOWLEDGMENTS

Thanks go to the dedicated staff at the Putnam County historian's office, including the late Richard Muscrella, present historian Allan Warnecke, his deputy Sallie Sypher, and the phenomenally knowledgeable and dedicated Reginald White, Carol Bailey, Christina Mucciolo, and Catherine Wargas; the Carmel Historical Society and its dedicated president Lillian Eberhardt and Mike Troy; the Taconic Postcard Club, including president Susan Lane, one of its founders, Denis Castelli, a member and cofounder, Michael Frank, FSA, and Dennis Nicholson.

Very little would be saved or built of the environment of Carmel without the tireless efforts of public servants, including the Honorable Robert J. Bondi, county executive; state senator Vincent Leibell; members of the Putnam County legislature; Sheriff Don Smith; and Frank Del Campo, former deputy county executive and former Carmel supervisor. I also wish to thank Danielle Cylich, the executive director of Preserve Putnam County; John Paul Spain for his generosity and support; and finally Barbara Subervi, my assistant, who typed and, truth be told, rewrote this book.

The author's proceeds from the sale of this book will be donated to local charities that support historic preservation.

INTRODUCTION

Through a carefully selected collection of postcards, *Carmel* reflects over 100 years of history of what has been called "the most beautiful town in America." Carmel is the seat of government in Putnam County and has the oldest continuously operated courthouse in the state of New York.

Putnam County is an area of low mountains and rocky terrain that was not particularly suitable for farming. As a result, early American colonists settled the more fertile lands of Westchester County, skipped over the band of mountains that now comprise Putnam County, and settled the broad valleys of Duchess County. Other than the Native Americans who inhabited the region, Putnam was sparsely settled by European colonists before the American Revolution.

Although founded in the 1700s, Carmel really came into its own when Putnam County was set off from Duchess County in 1812. Carmel then became the county seat, and the historic Putnam County Courthouse was build as an anchor to the town.

Postcards are a wonderful way to look at Carmel. My personal collection began many years ago at Cornish's Drug Store on Main Street. The store had a wonderful display of local postcards published by the Cornish family, members of whom have long been part of the fabric of Putnam County, serving as postmaster, pharmacist, and—most importantly for this book—publisher of many of the postcards contained in *Carmel*.

Since I have spent my whole life in Carmel, the book is somewhat nostalgic. It is not purposeless, however, because it is meant to inspire research and knowledge about the town's past and to encourage preservation of those buildings and natural sites that make Carmel "the most beautiful town in America."

—George Whipple

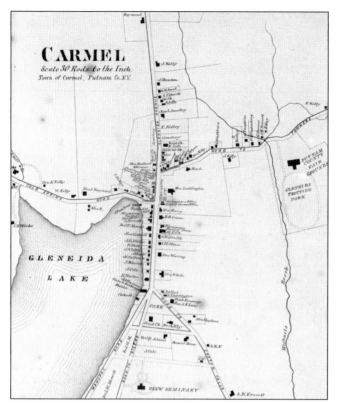

A Beers map of Carmel shows *c.* 1867 housing along the shore of Gleneida Lake and the Putnam County Fairgrounds and Racetrack.

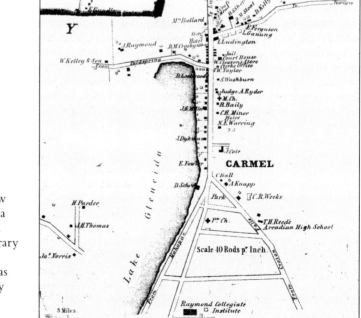

An 1854 map of Carmel shows a park at what is now the intersection of Gleneida Avenue and Seminary Hill Road where the Reed Library stands, and the Raymond Collegiate Institute that was later called Drew Seminary and is now the home of *Guideposts* magazine.

One

PUTNAM COUNTY COURTHOUSE

The Putnam County Courthouse was built shortly after the county was set off from Duchess County. The Greek Revival structure is the oldest continuously operated courthouse in the state of New York. One of the reasons that the courthouse has stood the test of time and that the county government has remained in Carmel is that the one-half acre of land underneath the courthouse was sold to the county by Dr. Robert Weeks for the purposes of a courthouse, and if the courthouse was to be moved, the land would be transferred to the Mount Carmel Baptist Church. That disincentive has kept the courthouse standing as the center of government in the village of Carmel.

Building the courthouse began in 1814 and was completed in 1815. In the 1840s, the Grecian portico and the belfry were added to the west facade and Greek Revival treatment was given to the entire building. Since the Greeks were the founders of democracy, Americans imitated the stone temples in wood as the successors of the democratic tradition.

County executive Robert Bondi and the Putnam County legislature revived the courthouse to its historic elegance. Jeffery Baker of the Mesick Cohen architectural firm in Albany carried out the meticulous restoration. The Mesick Cohen firm was the preeminent architect for historic Greek Revival structures, having the distinction of working on Thomas Jefferson's home, Monticello, in Virginia.

On display in the historic courtroom inside the courthouse is a life-size portrait of Gen. Israel Putnam, for whom the county is named. The portrait is on loan from the Whipple family, who also planted two Liberty elms, which are resistant to Dutch elm disease, in front of the courthouse to recreate the look of the building in the 1940s.

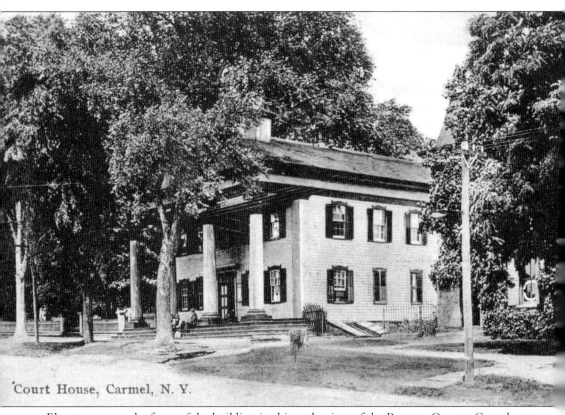

Court House, Carmel, N. Y.

Elm trees grace the front of the building in this early view of the Putnam County Courthouse in Carmel. Note that the courthouse served as a resting place for those who lounged.

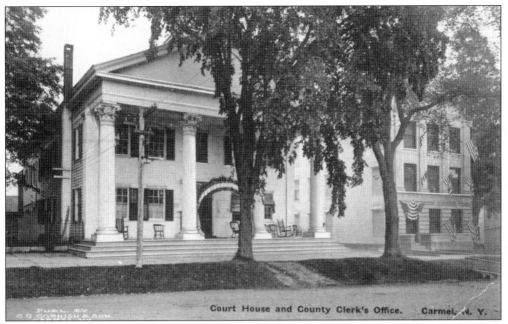

Court House and County Clerk's Office. Carmel, N. Y.

The entry of the Putnam County Courthouse is decorated in a red, white, and blue bunting for a celebration. The rocking chairs on the porch are a tradition that may one day be revived. Also in view is the Putnam County clerk's office.

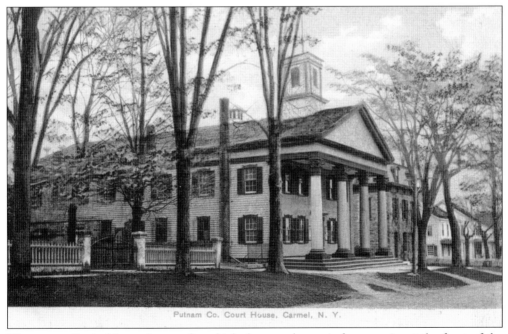

Putnam Co. Court House, Carmel, N. Y.

The ornate Corinthian columns, for which the courthouse is famous, rise at the front of the Greek Revival structure.

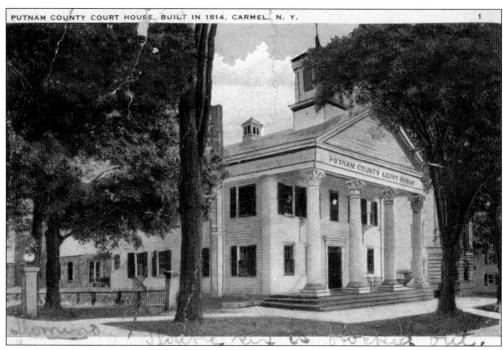

The words "Putnam County Court House" stand out clearly in this view of Carmel's elegant building.

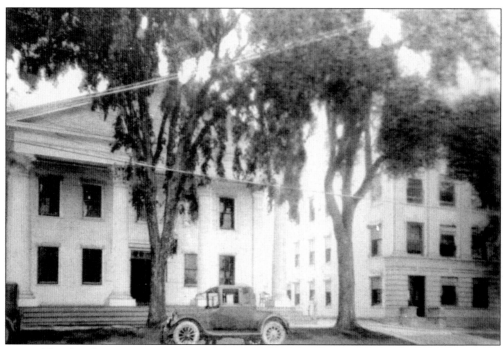

Framed by the elm trees, a Model A Ford stands in front of the Putnam County Courthouse in Carmel.

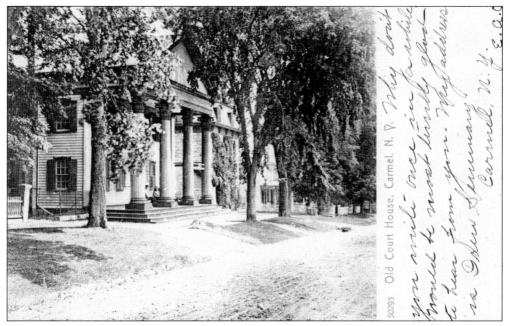

This early view of the Putnam County Courthouse is labeled "Old Court House, Carmel, N.Y." Even in the late 1800s, the building was considered old. The message on the right reads, "Why don't you write once in a while? Would be most terribly glad to hear from you. My address is Drew Seminary, Carmel, N.Y."

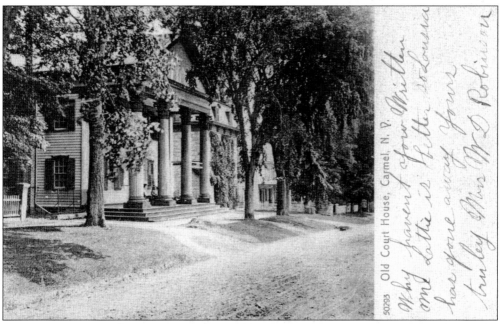

The note on the side of this "Old Court House" view says, "Why haven't you written me? Lottie is better, so Lousia has gone away. Yours truly, Mrs. W. D. Robinson." Robinson lived on the Whipple family farm at the time this postcard was sent.

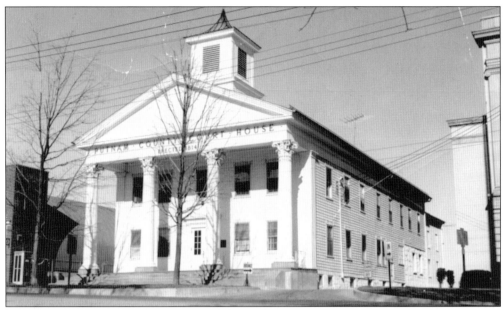

In this 1950s view of the Putnam County Courthouse, the electric wires are still visible. Note the old telephone booth (left), which was necessary in the days before cell phones.

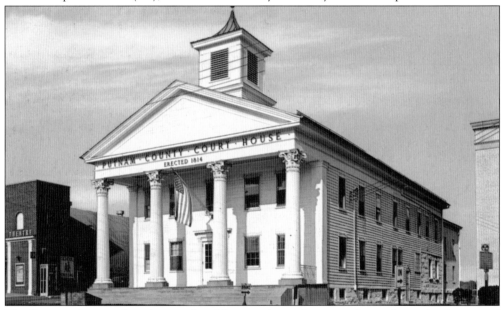

The Putnam County Courthouse, the oldest continuously operated courthouse in the state of New York, was erected in 1814, as the words on the front now show. The old Carmel Theatre (far left) had a brick facade but was merely a Quonset hut, bought as army surplus after World War II. The theater has now been demolished, and the lot awaits redevelopment by the Ryder family. The box under the School Crossing sign (left) contains a time capsule filled with historic artifacts to be opened sometime later this century. This 1960s photograph was retouched to hide the electrical wires that were still overhead at the time. Bob Bondi and the Putnam County legislature had the foresight to remove the wires in their entirety and bury them in the ground as part of the Main Street revitalization of Carmel.

Two

MAIN STREET

America's main streets and close-knit communities like Carmel are a product of a different age. In the 1700s, Putnam County was composed of small hamlets that were easily accessible by horseback on roads that were nothing more than trails. As the road system developed, larger towns developed that became the center of commerce and government. Carmel was one of these towns. It was a transportation hub and once boasted a stop on the Putnam division of the New York Central Railroad.

As roads became better and automobiles became ubiquitous, Main Street became irrelevant, supplanted by the glitzy commercial lure of shopping malls and mega stores. The commercialism of these shopping centers has led to nostalgic longing for the historic town centers of small shops, offices, churches, and government buildings, which resulted in a Main Street revitalization movement in the early part of this century. Carmel was restored and revitalized by Bob Bondi, county executive; the Putnam County legislature; Frank Del Campo, deputy county executive; and Sen. Vincent Leibell, who secured state funding.

In conjunction with local businessman John Spain and the Whipple Foundation who partnered together with Putnam County and the State of New York, Cornerstone Park was built at the historic crossroads of Fair Street and Gleneida Avenue. An abandoned gas station was transformed into a park and welcome center and officially named the Laura Spain Memorial Cornerstone Park in memory of John Spain's late sister. Victims of the World Trade Center tragedy of September 11, 2001, were honored with a monument erected in the southwest corner of the park. At the dedication of that monument, Sheriff Don Smith said that it was now "sacred ground."

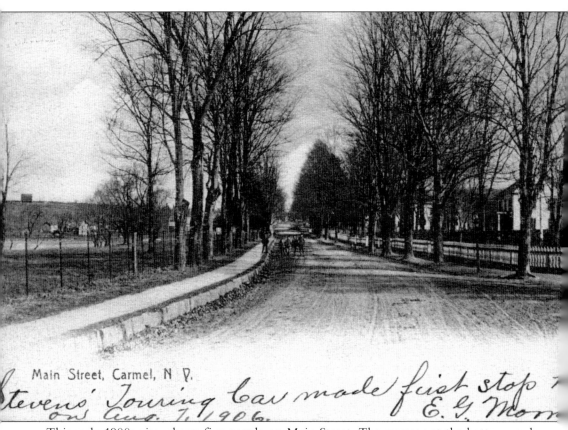

Main Street, Carmel, N. Y.

Stevens' Touring Car made first stop
on Aug. 7, 1906. E. G. Morr

This early-1900s view shows five people on Main Street. The message at the bottom reads, "Stevens' touring car made first stop here, on Aug. 7, 1906.—E. G. Morris."

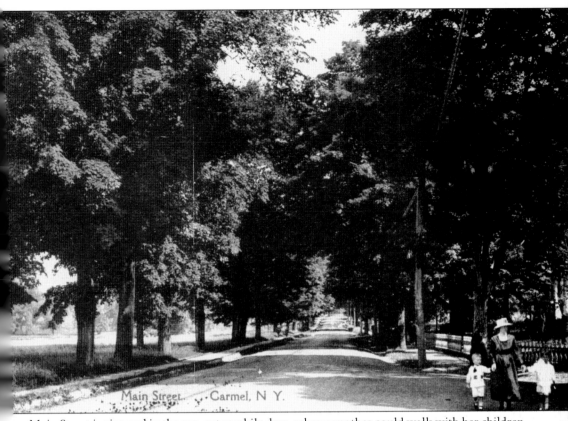

Main Street · Carmel, N.Y.

Main Street is pictured in the pre-automobile days, when a mother could walk with her children hand in hand and without fear of cars. Notice the fine clothes the woman and her boys are wearing. The quiet tree-lined street creates a very peaceful scene.

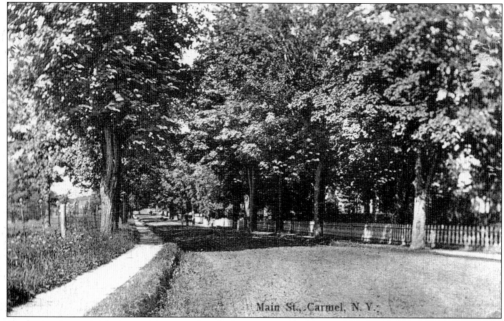

A solitary horse and carriage comes down the well-shaded lane alongside an extensively fenced Main Street property (right).

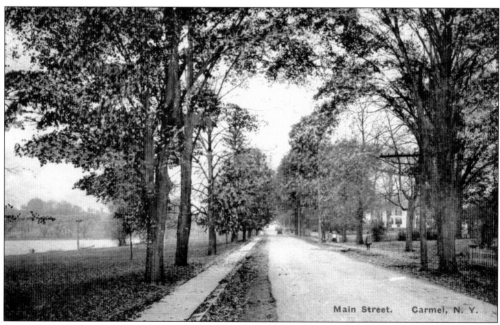

A Model T Ford rumbles down Main Street. A few pedestrians walk along the sidewalk, and Lake Gleneida sparkles in the sun. This was Main Street in the early days of automobiles, long before they filled the town.

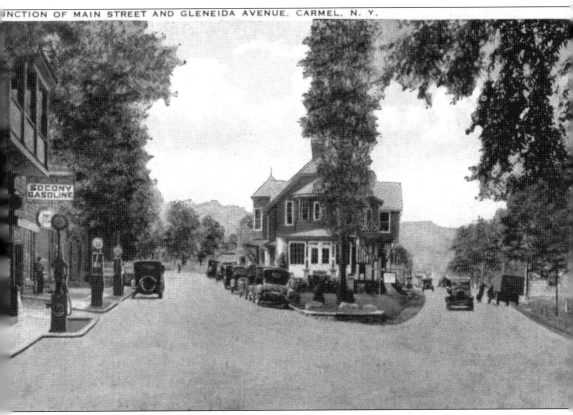

A Socony gasoline station with its three pumps stands ready to serve the numerous automobiles pictured in this view of Main Street where Seminary Hill Road meets Gleneida Avenue.

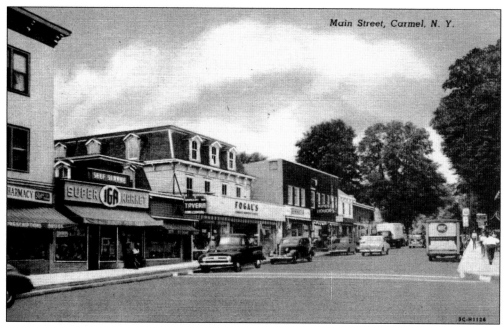

Main Street, also known as Gleneida Avenue, is pictured in the 1950s. Among the establishments are, from left to right, the Simpson Pharmacy, the IGA Self-Service Super Market, Smalles Tavern, Fogal's Five-and-Ten (now the site of the Carmel Diner), the Jessica shop, and a liquor store. Notice all of the vintage automobiles.

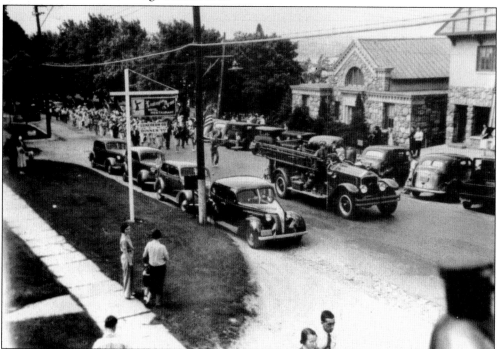

Everyone loves a parade. Out front in this 1930s parade is a fire truck passing by the Ryders' Putnam County National Bank and the sign for Ludington Arms Hotel and Restaurant. The Ludington Arms is still at the corner of Fair Street and Gleneida Avenue.

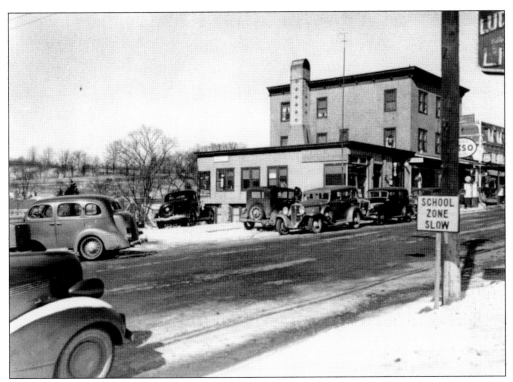

The Esso gasoline station appears to have a lot of customers. The station was on Gleneida Avenue in a school zone, according to the traffic sign, which says, "School Zone Slow."

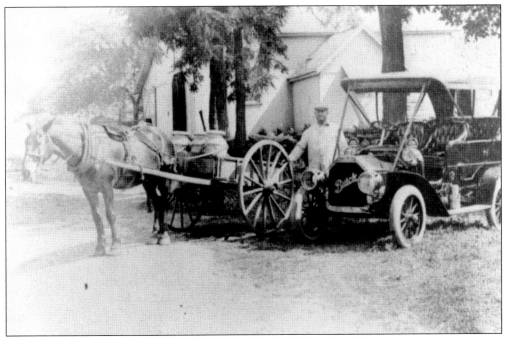

A large-wheeled horse cart, a man in cap and coat, and a small-wheeled Buick horseless carriage are pictured off Main Street.

Carmel, New York

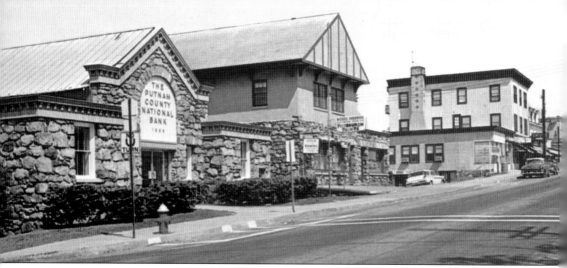

The stone-faced buildings in this view are, from left to right, the Putnam County National Bank, the Putnam County Courier, and Nickels Hardware. The view is looking up North Main Street in the 1960s.

Three

CHURCHES

Nothing sums up the village of Carmel more than the churches that are located there. The Mount Carmel Baptist Church and the Gilead Presbyterian Church are the oldest churches that are still active today. The stone Drew Methodist Church was built by Carmel resident and robber baron Daniel Drew and the Roman Catholic Church, a monument to 1960 architecture that faces Lake Gleneida and is reflective of the apostles' other career as fishermen.

The Gilead Presbyterian Church was, until 1774, of the Congregational denomination, making it one of the oldest churches in Carmel. The building that stands today dates from the 1920s. At one time public kindergarten was held in its basement.

The Mount Carmel Baptist Church has the distinction of being the first church built in the village of Carmel (Gilead was originally where the Gilead Cemetery is today). In 1836, the original church stood across the street from where the church is today. Its cemetery contains the remains of Revolutionary War soldiers and was restored by county historian Allan Warnecke. The present church dates from 1870. Its bell tower was the village's original fire alarm.

The Drew Methodist Church was first established in 1834 when local robber baron Daniel Drew provided most of the $40,000 needed for its construction.

St. James Catholic Church has had two homes; the first was a wooden structure on Brewster Avenue, and today it is a modern structure on Gleneida Avenue.

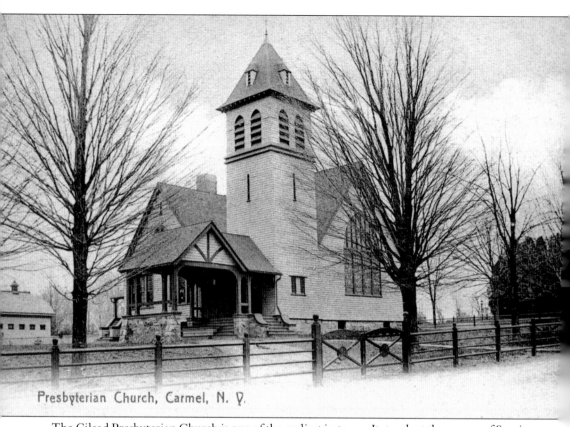

Presbyterian Church, Carmel, N. Y.

The Gilead Presbyterian Church is one of the earliest in town. It stands at the corner of Seminary Hill Road and Church Street. Public kindergarten was once taught in the church basement.

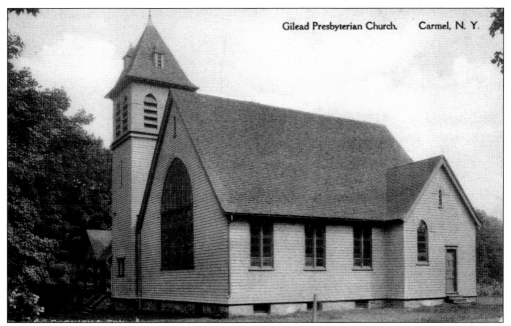

Gilead Presbyterian Church. Carmel, N. Y.

These are two other views of the Gilead Presbyterian Church, which is also known as just the Presbyterian Church.

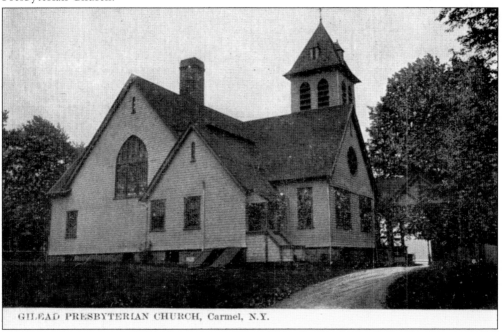

GILEAD PRESBYTERIAN CHURCH, Carmel, N.Y.

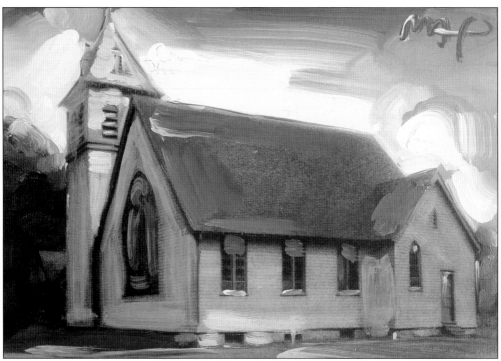

These two paintings of the Gilead Presbyterian Church are by famous 1960s pop artist Peter Max.

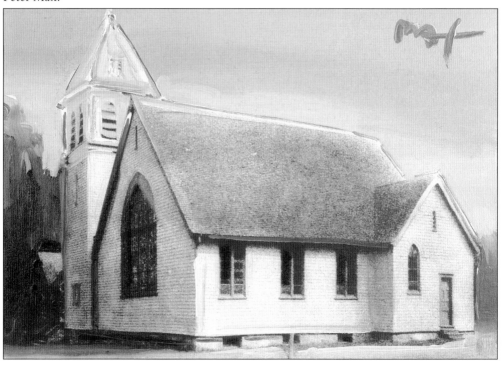

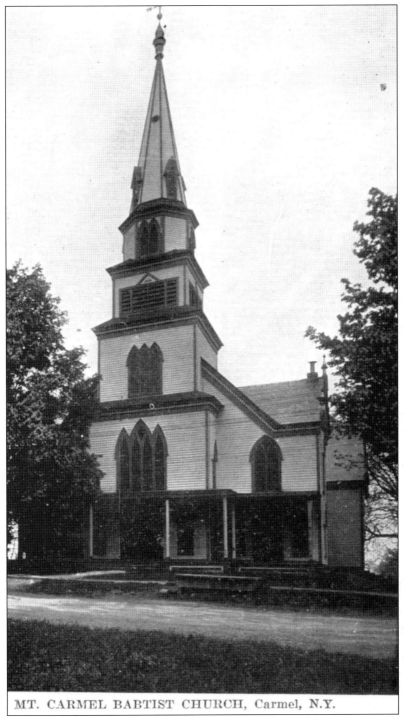

MT. CARMEL BABTIST CHURCH, Carmel, N.Y.

The Mount Carmel Baptist Church is adorned with Gothic Revival ornamentation. Originally this was probably a Federal church. The building was modernized in the period of prosperity that followed the opening of the railroad into Putnam County. The railway allowed local farmers to have their milk delivered to New York City.

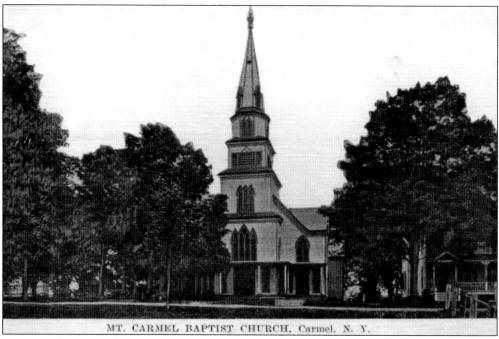

MT. CARMEL BAPTIST CHURCH, Carmel, N. Y.

The Mount Carmel Baptist Church was moved to this location. It is one of the oldest in the county, having been chartered by the Phillips family in the late 1700s. The extraordinary early photograph shows a full moon rising over the church.

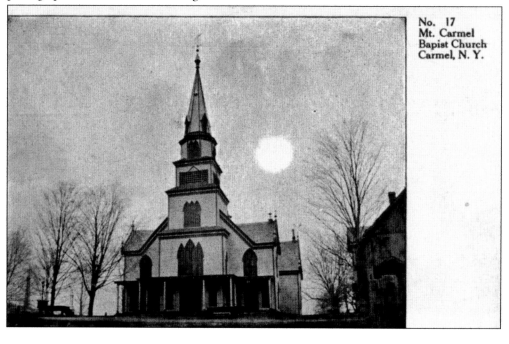

No. 17
Mt. Carmel
Bapist Church
Carmel, N. Y.

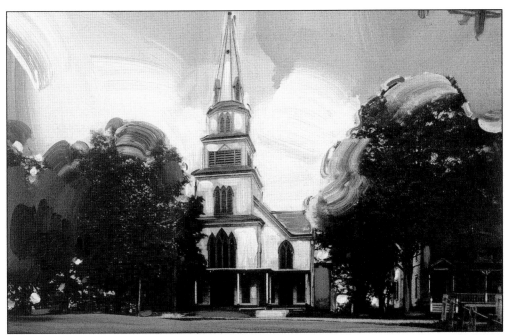

Using a postcard image, pop artist Peter Max painted these two portraits of the Mount Carmel Baptist Church. Both paintings are on display in the welcome center at Spain Cornerstone Park.

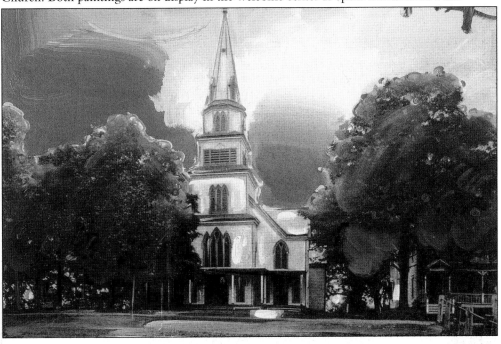

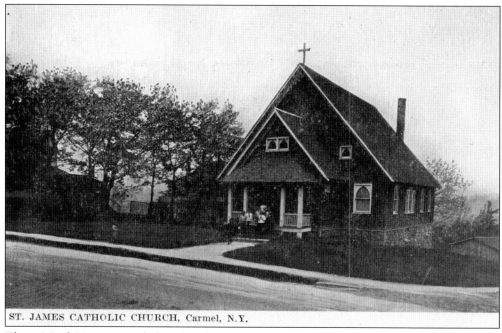

ST. JAMES CATHOLIC CHURCH, Carmel, N.Y.

The original St. James Catholic Church stood on Brewster Avenue. It is now demolished.

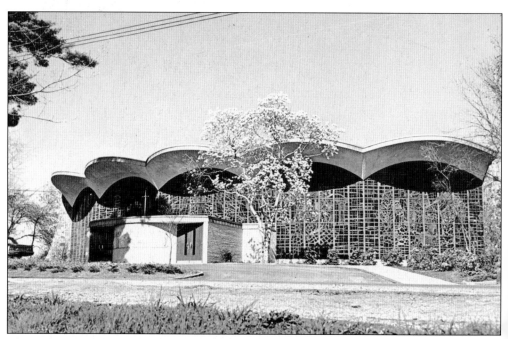

This St. James Catholic Church was built on Gleneida Avenue in the 1960s. Considered an architectural masterpiece, it has a shell-shaped design and a fishing-boat bow for a pulpit, both meant to remind parishioners of the original career of the apostles as fishermen.

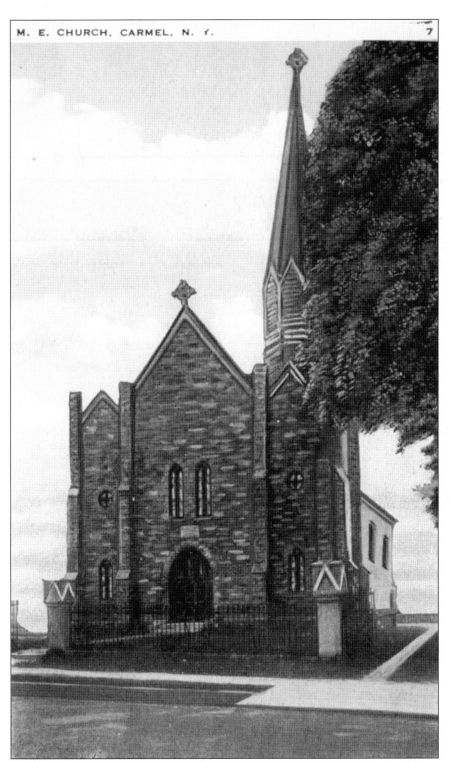

The stone Drew Methodist Episcopal Church is named for local robber baron Daniel Drew. This view shows the full facade of the impressive building.

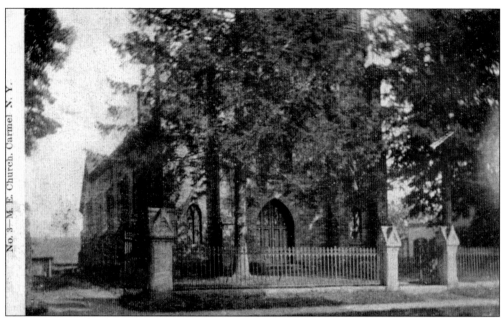

These two views show the Drew Methodist Episcopal Church before the modern entryway was added and the spire was removed.

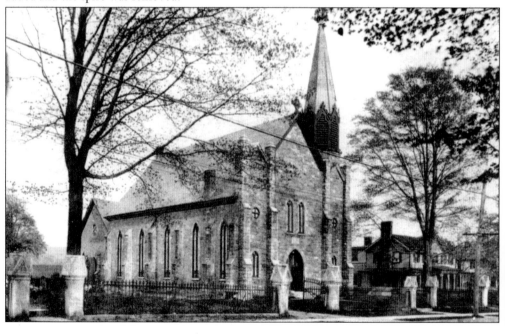

Four

DREW SEMINARY

Drew Seminary, an institute of higher learning, was originally known as the Raymond Institute (1848–1866). Presumably it was named after the same family who lived where Raymond Hill Cemetery is now located. On May 4, 1866, it was renamed for financier and robber baron Daniel Drew after a contribution of $25,000 and opened as an institute for the education of young women. Drew was a local farmer who went on to become a Wall Street speculator in the period that followed the Civil War. He was known as the originator of "watered stock." He drove cattle belonging to Putnam County farmers (which he sometimes took on credit and never paid for) down Peekskill Hollow Road to be loaded on barges and shipped to New York City. Before the cattle could be weighed to determine their price, he fed them raw salt and then let them drink their fill, increasing their weight by eight pounds for each gallon of water the cows consumed. By this savvy maneuver, he increased the amount of money he received for his cattle. He later tried the same technique with shares of stock. He gained control of a company and issued unlimited shares. In this way he sold shares and pocketed the money but diluted the stocks value so that it was worthless. The seminary campus is occupied by *Guideposts* magazine today.

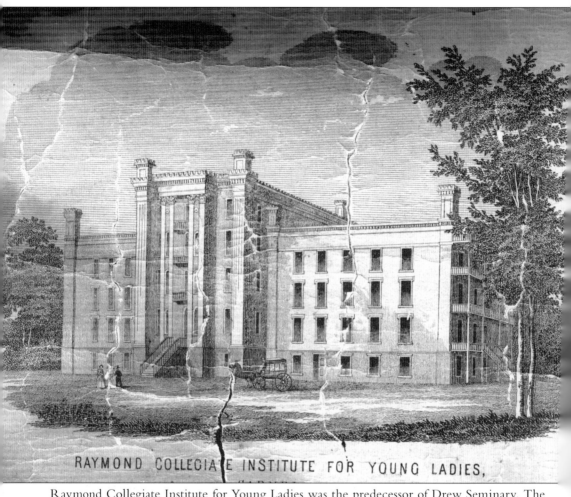

RAYMOND COLLEGIATE INSTITUTE FOR YOUNG LADIES,

Raymond Collegiate Institute for Young Ladies was the predecessor of Drew Seminary. The beautiful castlelike building used to sit on Seminary Road.

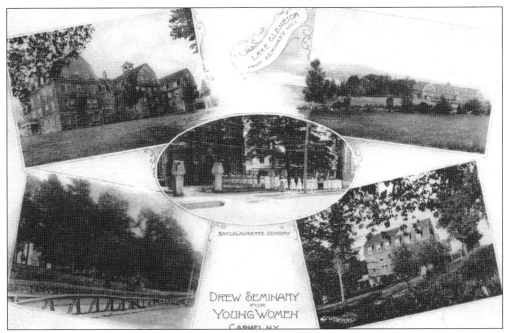

This card offers an overview showing the buildings and activities of Drew Seminary for Young Women in Carmel. Included are a Baccalaureate Sunday at the Drew Methodist Church on Gleneida Avenue and the Seminary Hill Bridge leading up to the seminary.

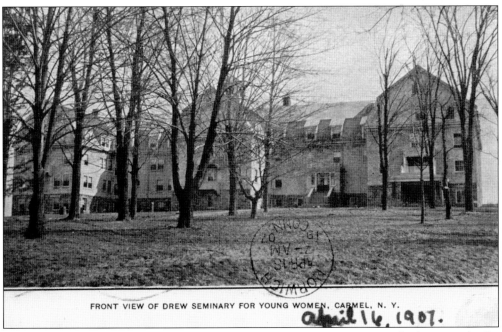

FRONT VIEW OF DREW SEMINARY FOR YOUNG WOMEN, CARMEL, N. Y.

A front view of Drew Seminary for Young Women shows numerous trees in the foreground. The card was postmarked at 7:00 a.m. April 18, 1907, in Norwich, Connecticut. The handwritten date at the bottom is two days earlier.

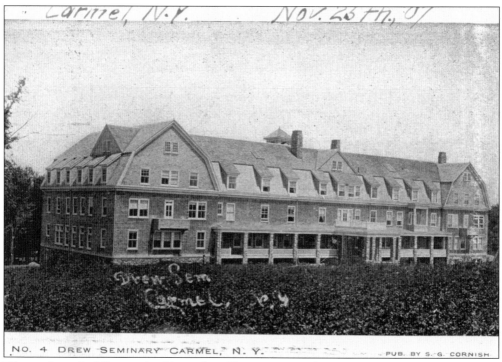

The seminary building evolved into a barnlike structure. This postcard was published by S. G. Cornish, and the date written at the top is November 25, 1907.

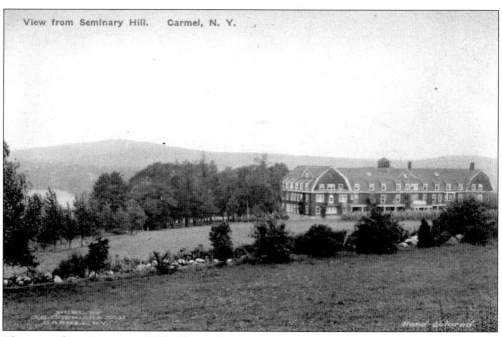

This view from Seminary Hill offers a glimpse of Lake Gleneida in the background and the steeple of the Mount Carmel Baptist church barely visible beyond. The postcard is marked "hand colored" and published by "S. G. Cornish and Son, Carmel, N.Y."

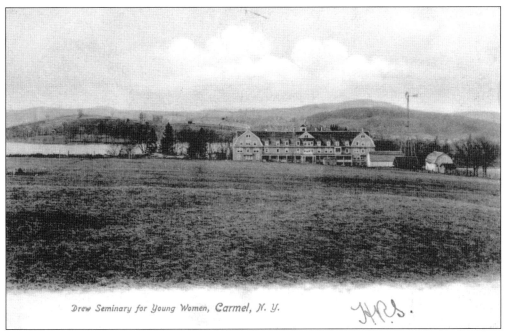

A distant view of Drew Seminary for Young Women on Seminary Hill Road shows Lake Gleneida in the background. A windmill used to pump water is seen to the right of the building. The handwritten initials at the bottom appear to be H. R. S.

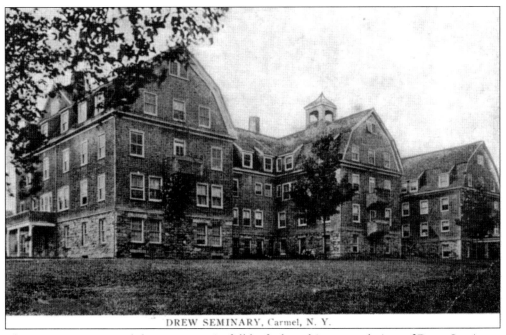

The grass was green and the trees were in full leaf when this postcard view of Drew Seminary was taken.

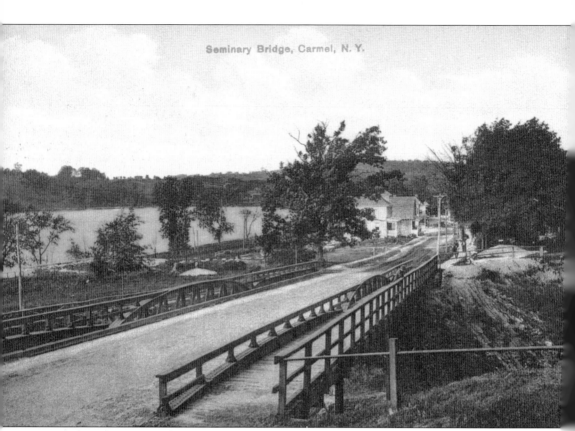

Seminary Bridge, Carmel, N. Y.

The Seminary Bridge went over the railroad tracks. Lake Gleneida lies in the left distance.

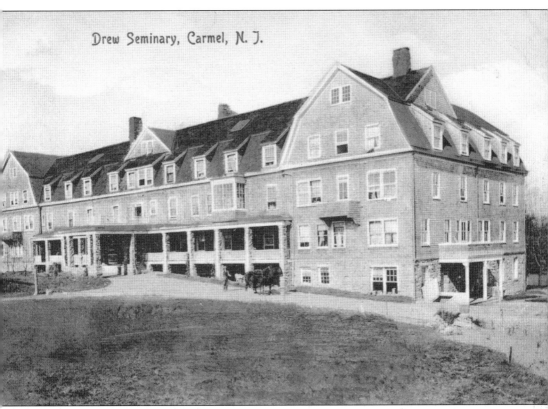

Drew Seminary, Carmel, N. J.

Drew Seminary is shown with a horse team stopped out front. This early view is extremely rare because it is identified at the top as being located in Carmel, New Jersey.

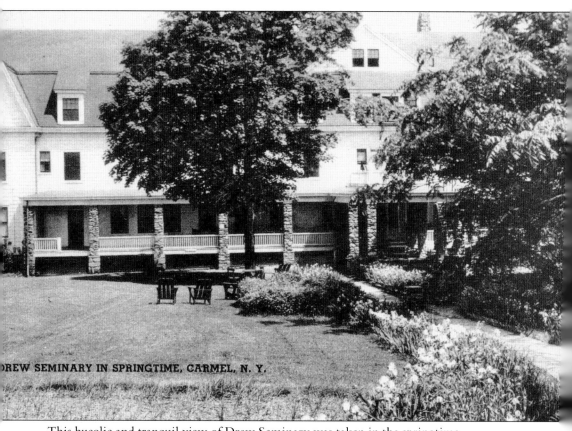

DREW SEMINARY IN SPRINGTIME, CARMEL, N. Y.

This bucolic and tranquil view of Drew Seminary was taken in the springtime.

Five

THE BUILT ENVIRONMENT

Nothing tells the story of Carmel better than the buildings that have been erected there over the years. There were many periods of prosperity that led to building activity in the town. The first period was when Putnam County was set off from Duchess County in 1812 and the courthouse and other municipal buildings and private residences were built. The pre–Civil War period saw many classic American buildings erected. In the late 1800s, the Gothic Revival craze swept the town, fueled by the money brought to local farmers by their ready access to New York City markets due to the Putnam Division Railroad making its way into Carmel. After the automobile was introduced, it had a profound effect on the town by bringing in tourists and businesses. During the 1960s and 1970s, the exodus from New York City to the surrounding suburbs caused another building boom.

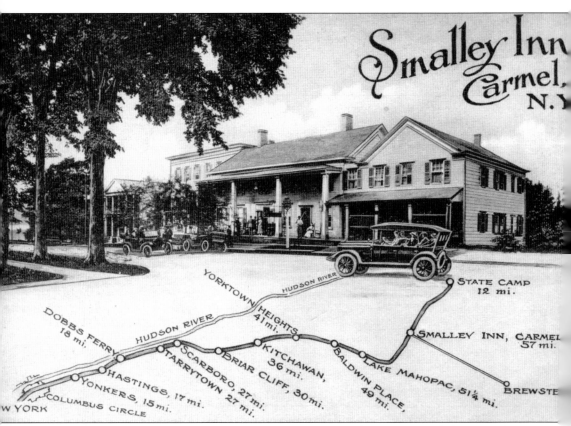

The Smalley Inn is one of the lasting landmarks in Carmel. This postcard includes a map showing how to get from Columbus Circle in New York City to the inn. A delightful 1920s automobile shows the 57-mile route up the Hudson River and out to Smalley Inn. The places along the way and their mileage from New York City are also shown.

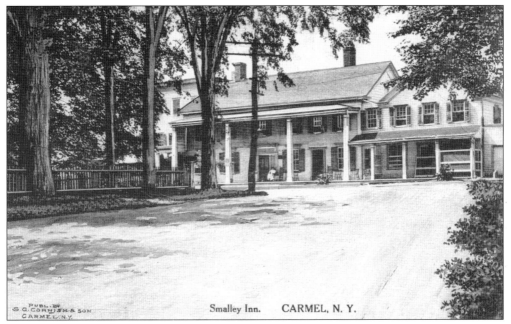

A woman in a long, flowing dress relaxes in a rocking chair on the porch of Smalley Inn. There is not an automobile in sight. The front of the postcard is marked, published by "S. G. Cornish and Son, Carmel, N.Y."

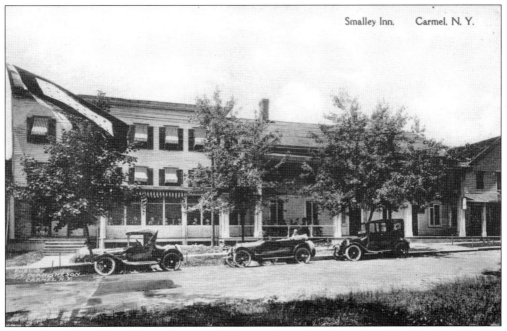

A good number of people can be seen dining on the enclosed porch at Smalley Inn. Outside on Gleneida Avenue, three automobiles—a Model A, a small convertible, and a Model T—wait patiently for the diners to finish their meal.

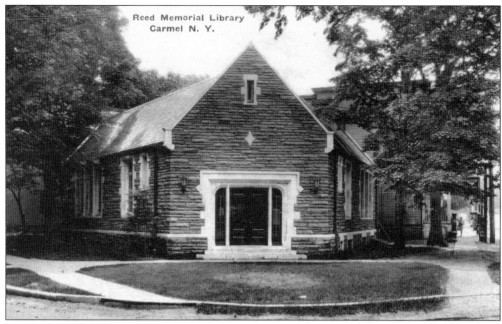

Reed Memorial Library was the successor to the Carmel Literary Union. The library was built on land donated by the Ryder family.

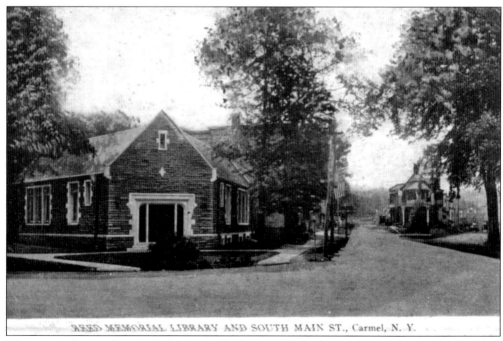

This postcard view shows Reed Memorial Library and South Main Street.

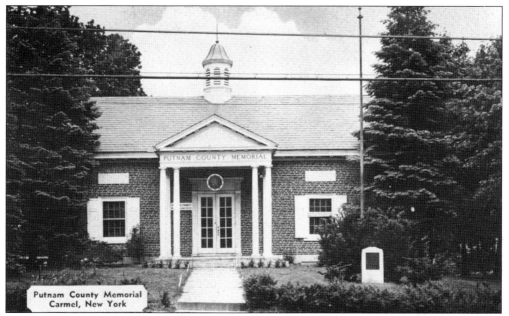

Putnam County Memorial
Carmel, New York

Putnam County Memorial was dedicated to the memory of the military heroes of Putnam
County. Known locally as Memorial Hall, the building was used for Peggy Donnelly's dancing
lessons in the 1960s.

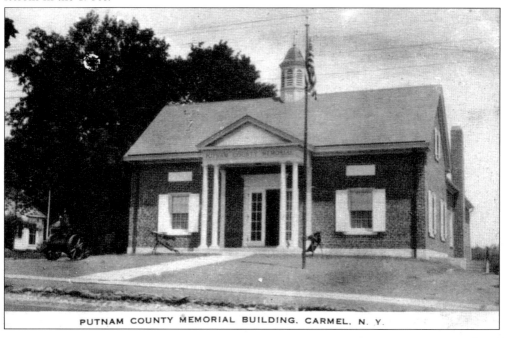

PUTNAM COUNTY MEMORIAL BUILDING. CARMEL, N. Y.

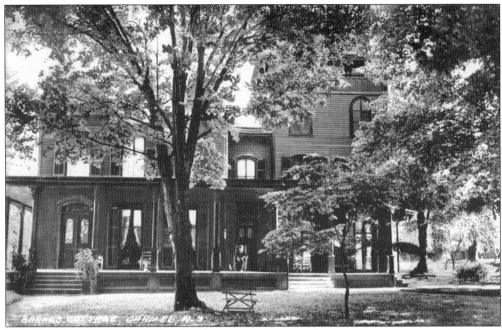

Located in Carmel, the Barnes Cottage was a handsome Italianate structure. One of the front porch rocking chairs is occupied.

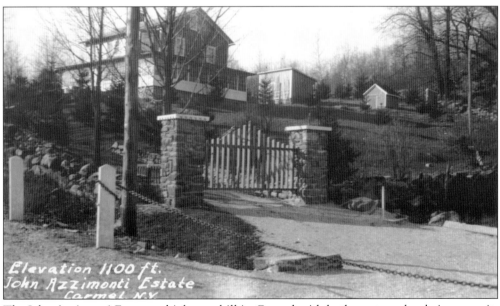

The John Azzimonti Estate sat high on a hill in Carmel with both a gate and a chain across its driveway. The notation at the lower left indicates that the elevation is 1,100 feet.

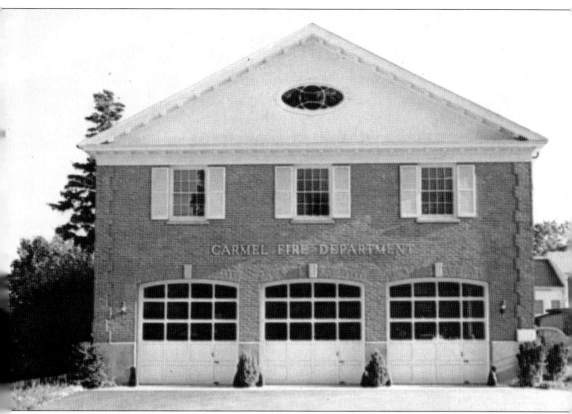

The Carmel Fire Department was housed in this handsome three-bay station. The view dates from the 1960s. The building is now the Knights of Columbus Hall.

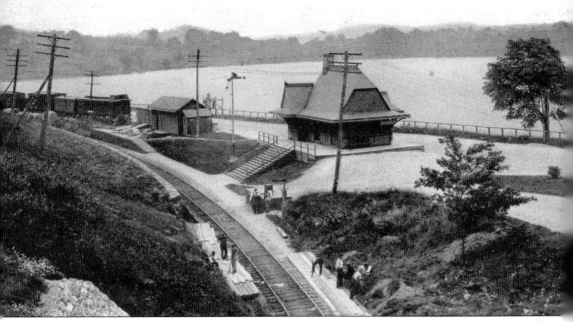

The Carmel Railroad Station for the Putnam Division of the New York Central Railroad stands across from the shore of Lake Gleneida. At least four boxcars sit on the siding, and a crew of men appears to be working alongside the tracks. This is a hand-colored view of the depot.

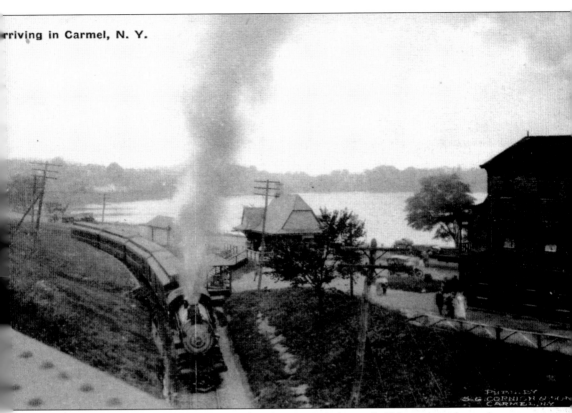

A steam engine pulls into the Carmel Railroad Station. At least a half dozen people can be seen down by the track, and four boxcars can be seen in the left distance.

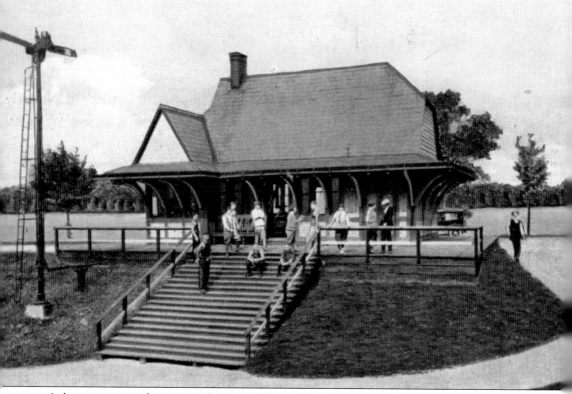

A dozen or so people appear to be waiting for the train to arrive at the Carmel Railroad Station. Note the early automobile behind the depot.

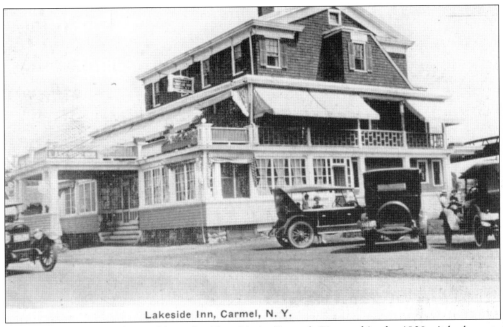

Lakeside Inn, Carmel, N. Y.

The Lakeside Inn was located by Lake Gleneida in Carmel. Pictured in the 1930s, it had guests seated outdoors and four automobiles parked outside. Later in the day, seven young people play on the stone-edged grass triangle that surrounds the flagpole in front of the inn.

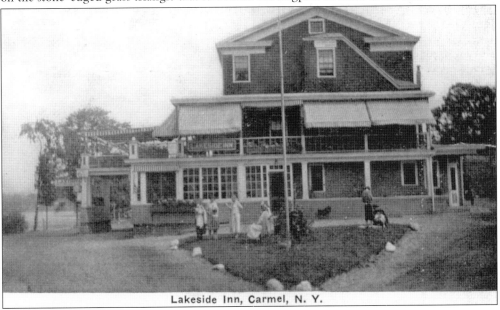

Lakeside Inn, Carmel, N. Y.

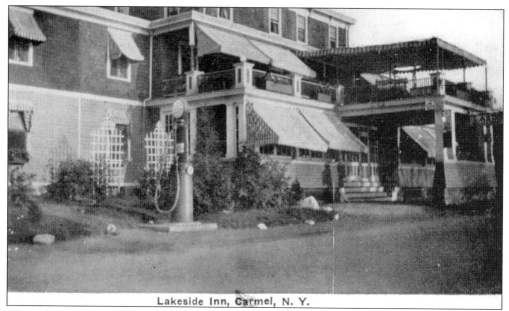

Lakeside Inn, Carmel, N. Y.

The Lakeside Inn even has its own gas pump. A screen door from the porch leads inside the inn to a wainscoted room. The room is furnished with a small table holding books, magazines, and a Tiffany-style lamp wired to an overhead light; four chairs; a glass cabinet filled with items that guests might need; two paintings; and an Oriental-style rug. Through the open doorway is what appears to be the dining room. The lower postcard notes that Mealey and Mahony were proprietors at the time.

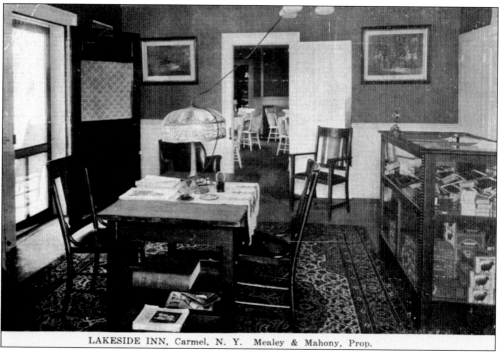

LAKESIDE INN, Carmel, N. Y. Mealey & Mahony, Prop.

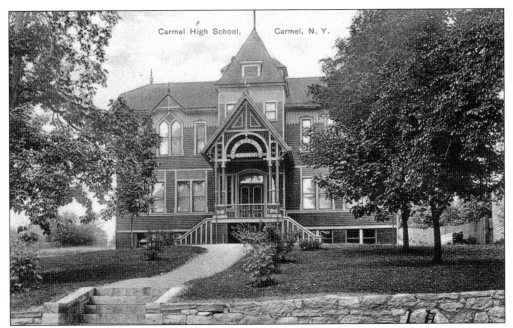

Carmel High School was originally an ornate gingerbread building, with a double set of steps at the entrance. It was set back from a stone wall and was surrounded by nicely landscaped grounds.

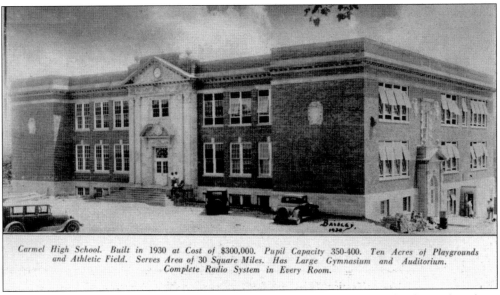

Carmel High School. Built in 1930 at Cost of $300,000. Pupil Capacity 350-400. Ten Acres of Playgrounds and Athletic Field. Serves Area of 30 Square Miles. Has Large Gymnasium and Auditorium. Complete Radio System in Every Room.

This high school was built on Fair Street in 1930 at a cost of $300,000. The school served residents within a 30-square-mile area and held up to 400 pupils. The facility included a "complete radio system in every room," a large gymnasium and auditorium, and 10 acres of playgrounds and athletic fields. Note the three students at the front entrance and another three at the open side door. The postcard bears a name and date: "Baisley 1930."

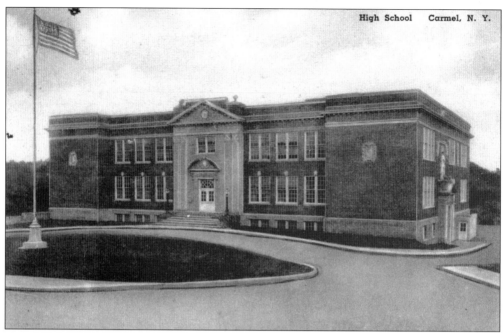

The Carmel High School still stands today on Fair Street. In recent years the building has been expanded to meet Carmel's current educational needs.

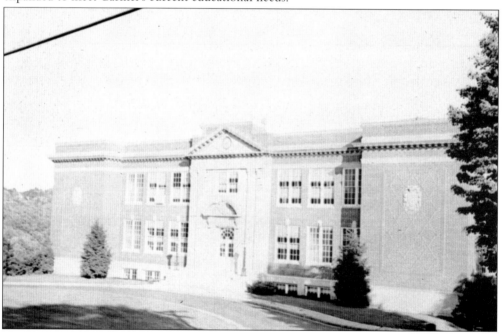

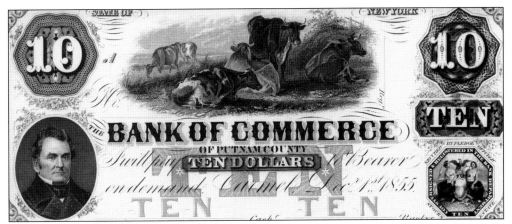

Pictured are two bank notes from the mid–1800s, both marked "Carmel." The one above reads, "Bank of Commerce," which was the predecessor of the Putnam County National Bank. Dated 1855, it shows six cows in a pasture and states that it "will pay ten dollars to the bearer on demand." The one below reads, "Bank of Commerce of Putnam County." Dated 1861, it shows three human figures and states that it "will pay five dollars to the bearer on demand."

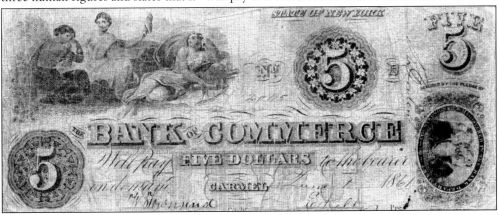

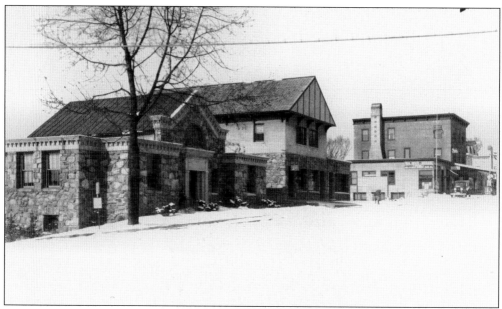

The Ryders' Putnam County National Bank (above) is pictured in the 1930s. Early members of the Ryder family also had their own money—National Bank Notes signed by the Ryders. Putnam County National Bank (below) stands surrounded by snow.

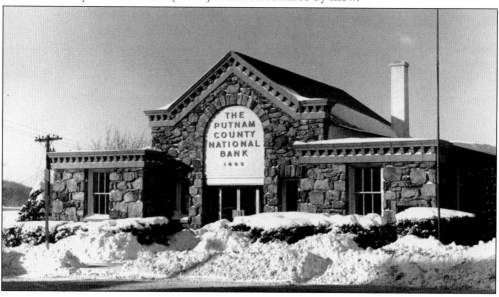

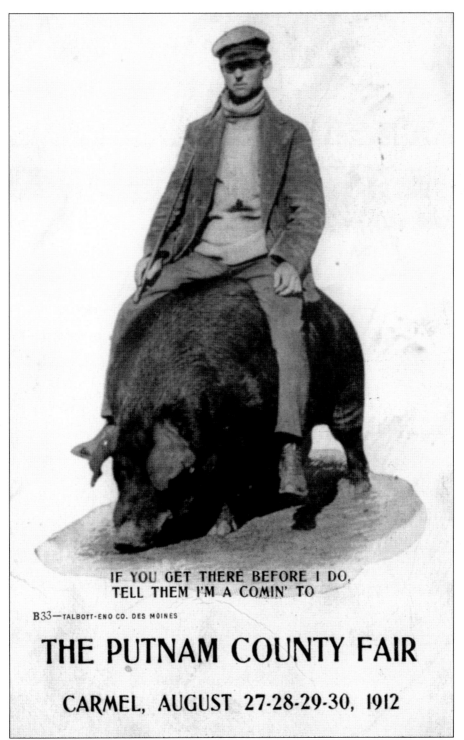

A man astride a hog is featured in this poster advertising the Putnam County Fair. "If you get there before I do, tell them I'm a comin' to the Putnam County Fair, Carmel, August 27–28–29–30, 1912."

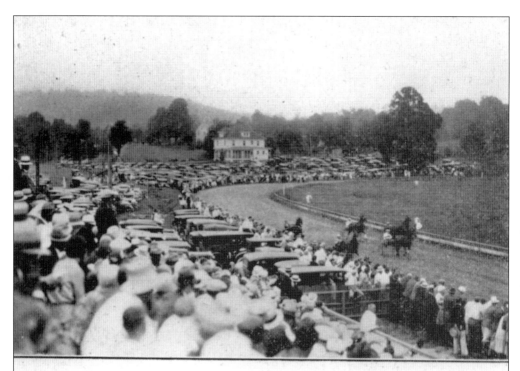

*View of Part of Crowd Watching Start of Race at a Weekly Matinee
Note Motor Cars Parked Near Residence.*

Racing fans watch the trotters at the weekly matinee at the Putnam County Agricultural Fair Racetrack off Fair Street east of the high school. A notable number of parked automobiles can be seen in the distance (above). The grandstand (below) held a huge crowd.

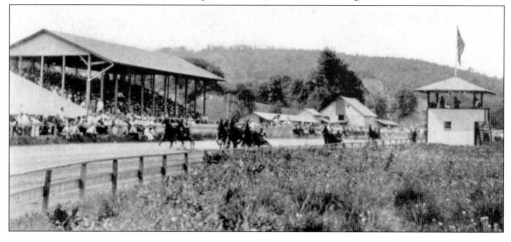

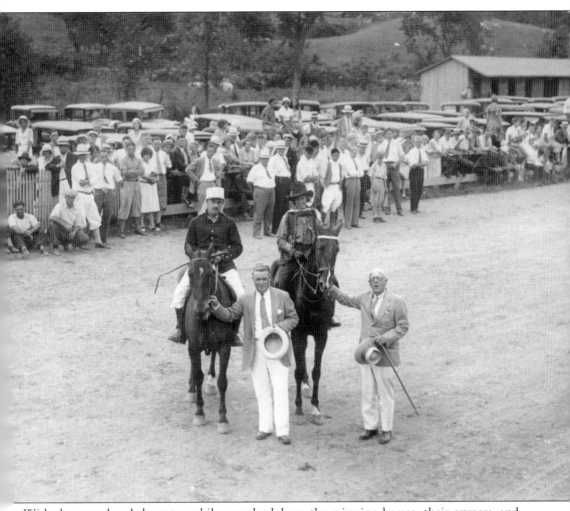

With the crowd and the automobiles as a backdrop, the winning horses, their owners, and their riders pose for a photograph after the race. This photograph shows the Gipsy Trail Club participation in Jymkhana, on horseback are Alpha R. Wheton and Mrs. Gunnison.

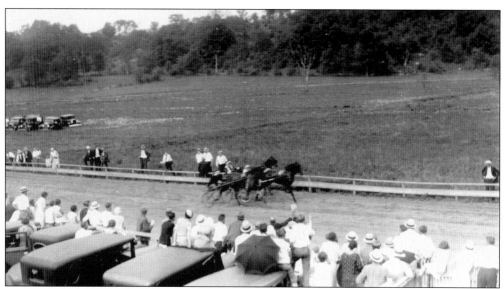

The excitement builds. Racing fans lean forward and cheer for their horses as the trotters speed by (above). Mrs. Fred Smith is shown below in 1931.

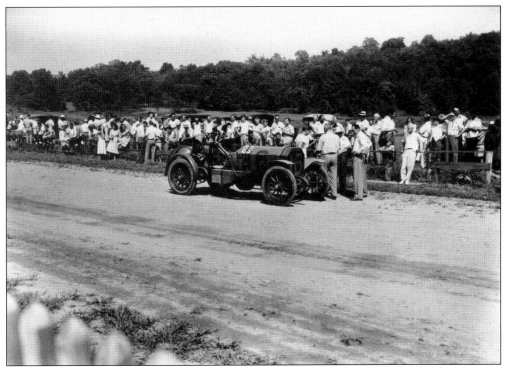

A new, speedier breed of racer comes to the Carmel track, and the crowd presses in close. As the time for horses passed and the age of automobiles dawned, the Carmel track gave way to racing the internal combustion engine.

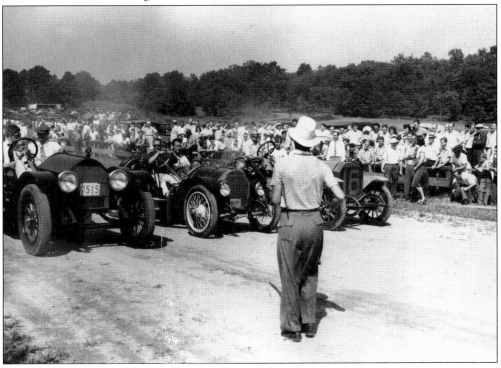

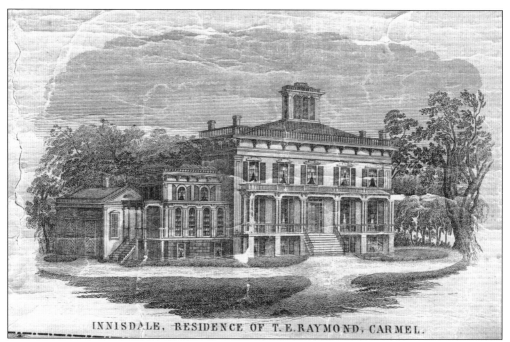

INNISDALE, RESIDENCE OF T. E. RAYMOND, CARMEL.

Innisdale was the Carmel residence of T. E. Raymond, who endowed the Raymond Institute, which later became Drew Seminary.

This old Carmel home stood on the site where the new courthouse stands today. It was known as the Blake residence and housed the Putnam Republican office then Putnam Motor Sales and now the county clerk's office.

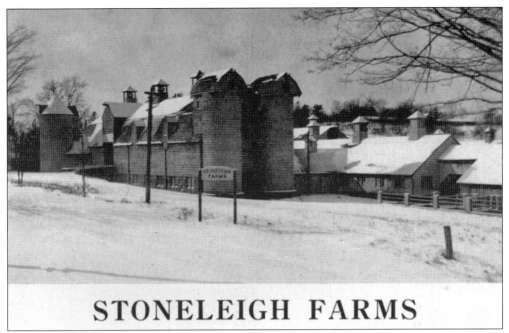

STONELEIGH FARMS

Stoneleigh Farms was one of the huge dairy farms in the Carmel area. It was owned by Burton F. White at the time this view was made. The barns were reconstructed and converted to medical offices by Dr. John Simmons after they burned. Similar to garage sales, barn sales were once held at this structure, which was located across from the Putnam Hospital Center.

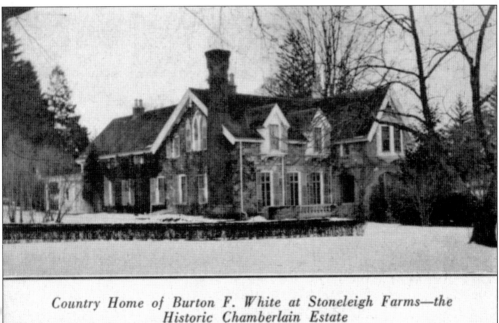

Country Home of Burton F. White at Stoneleigh Farms—the Historic Chamberlain Estate

The manor house at Stoneleigh Farms served as the country home of Burton F. White. It was originally the historic Chamberlain Estate. The house was located on Stonely Avenue on the present-day site of Vista on the Lake Condominiums.

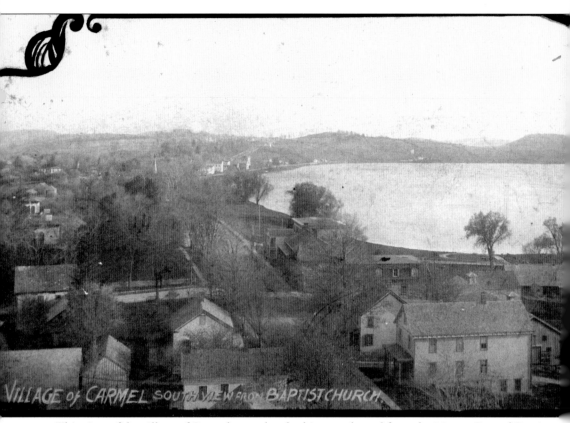

This view of the village of Carmel was taken looking southward from the Mount Carmel Baptist Church steeple sometime after 1893. Notice that the houses have already been removed from the shore of Lake Gleneida.

Six

LAKE GLENEIDA

Lake Gleneida is the visual center of the hamlet of Carmel. It acts much like a gigantic village green in a picturesque New England village. Originally it was known as Shaws Pond, named for an early resident of the county.

In 1893, New York City took possession of the bottom of the lake and forced all the buildings to be removed from the lakeshore. The natural beauty of the lake and recent efforts to enhance the shoreline are dominant features that qualify Carmel as one of the most beautiful towns in America.

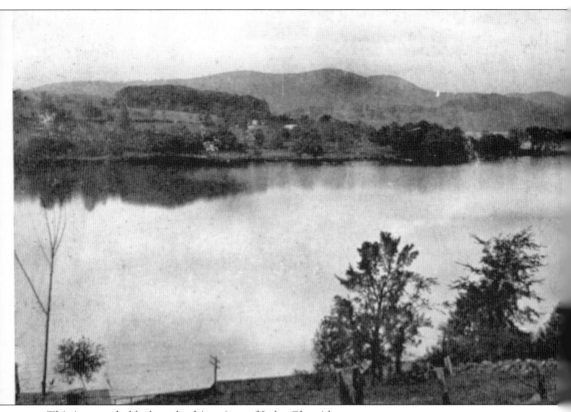

This is an early black-and-white view of Lake Gleneida.

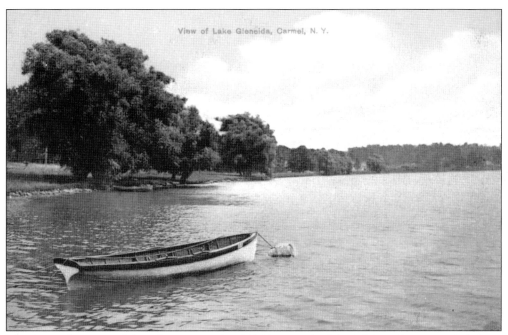

View of Lake Gleneida, Carmel, N. Y.

The City of New York has always permitted fishing on the lake. This early postcard shows a long wooden rowboat moored to a wooden beer barrel on the lakeshore.

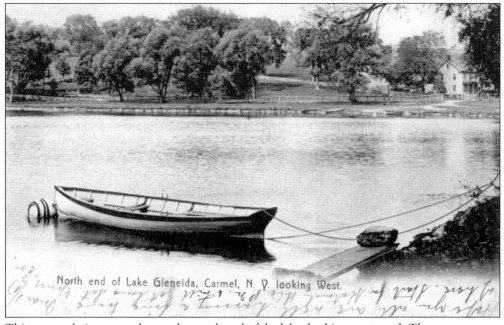

North end of Lake Gleneida, Carmel, N. Y. looking West.

This postcard view was taken at the north end of the lake, looking westward. The message says, "Hope you all are well. Having a fine time up here. Start for Katanah this p.m. and will get home Sat[urday]. Yours, Ev." The handwritten date appears to be March 1, 1907.

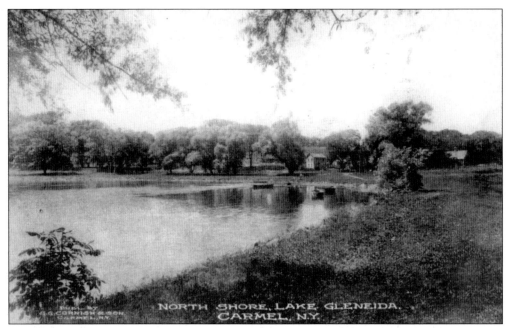

S. G. Cornish and Son of Carmel published this beautiful view of the north shore of Lake Gleneida. The Cornish family is responsible for the many postcard images in this book.

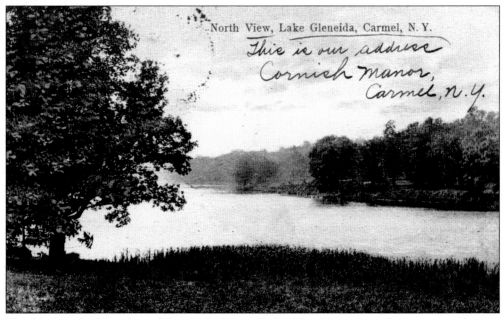

North View, Lake Gleneida, Carmel, N.Y.

This is our address
Cornish Manor,
Carmel, n.y.

This black-and-white view of the north shore of Lake Gleneida was sent by someone who was staying at Cornish Manor, an early hotel in Carmel.

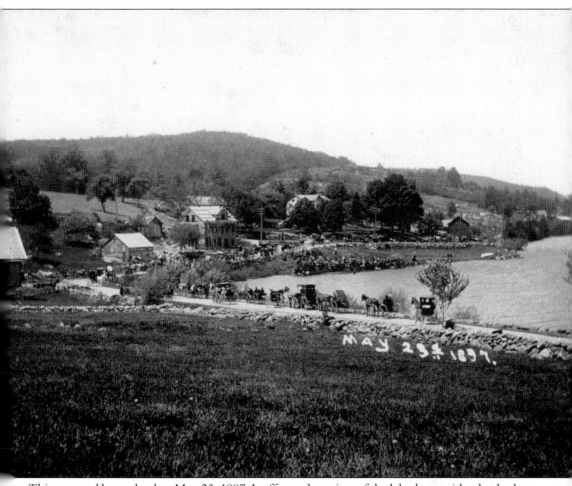

This postcard bears the date May 23, 1897. It offers a clear view of the lakeshore with what looks like a horse-and-buggy traffic jam.

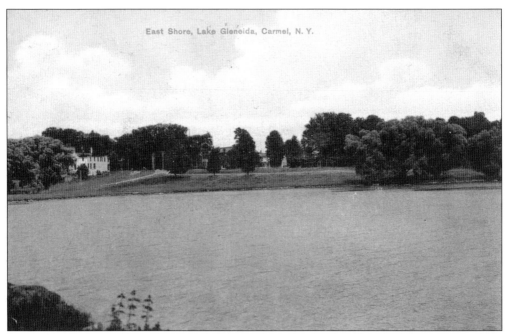

This is a view of the eastern shore of Lake Gleneida after the lakeshore buildings have been removed. One can just glimpse the courthouse in a group of trees on the other side of Gleneida Avenue.

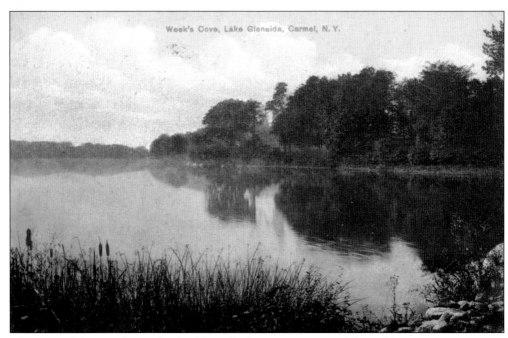

The view of the east shore of Lake Gleneida shows a very peaceful Week's Cove.

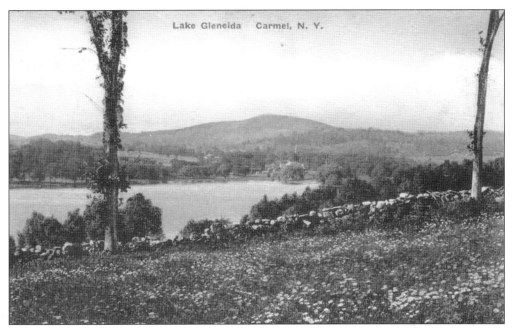

Lake Gleneida Carmel, N. Y.

Here are two similar views taken from Seminary Hill looking down on the lake. The one above is a colored postcard, and the one below is a black–and–white version. Notice the Mount Carmel Baptist Church steeple in the distance.

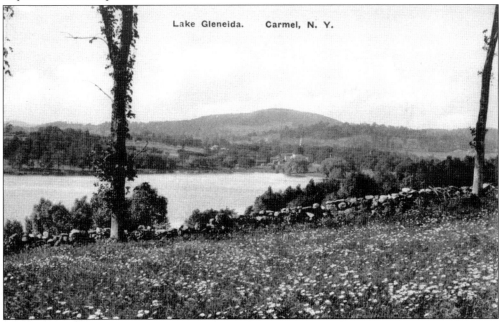

Lake Gleneida. Carmel, N. Y.

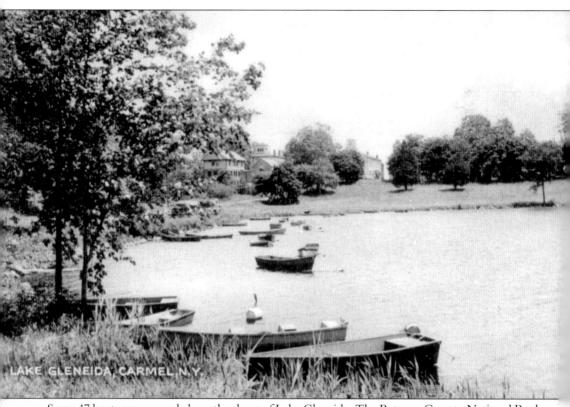

LAKE GLENEIDA, CARMEL, N.Y.

Some 17 boats are moored along the shore of Lake Gleneida. The Putnam County National Bank (center) and the Putnam County Courthouse (right) are visible in the background.

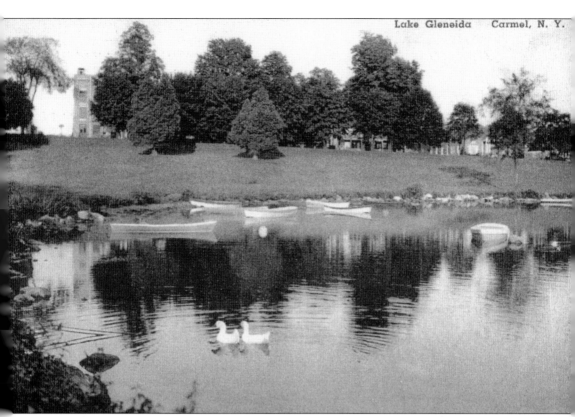

Two white geese set the peaceful tone of this Lake Gleneida scene. In the background, the Putnam County office building stands, as it still does today.

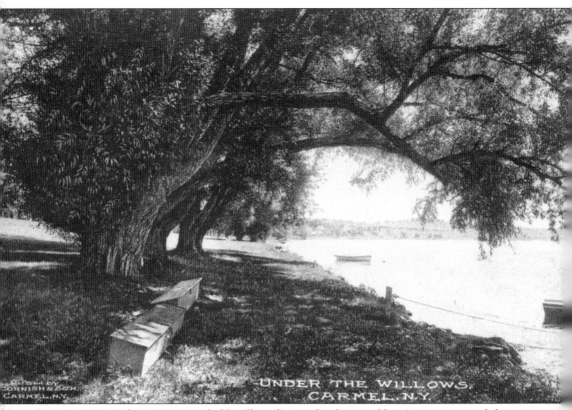

At some point there were grand old willows lining the shore and leaning over toward the waters of Lake Gleneida. This early postcard was published by S. G. Cornish and Son of Carmel.

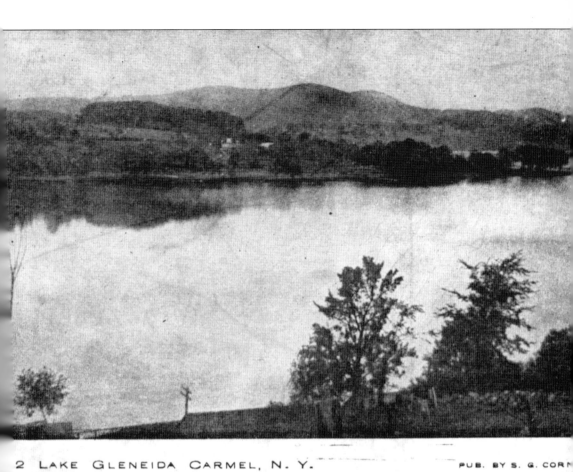

2 LAKE GLENEIDA CARMEL, N. Y. PUB. BY S. G. CORN

This lovely view is from an early set of postcards published by S. G. Cornish. It shows Lake Gleneida with the mountains in the distance.

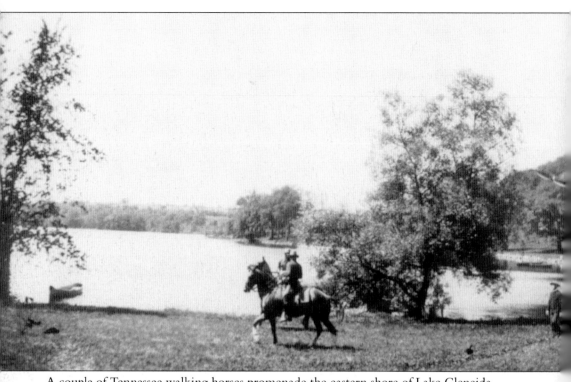

A couple of Tennessee walking horses promenade the eastern shore of Lake Gleneida.

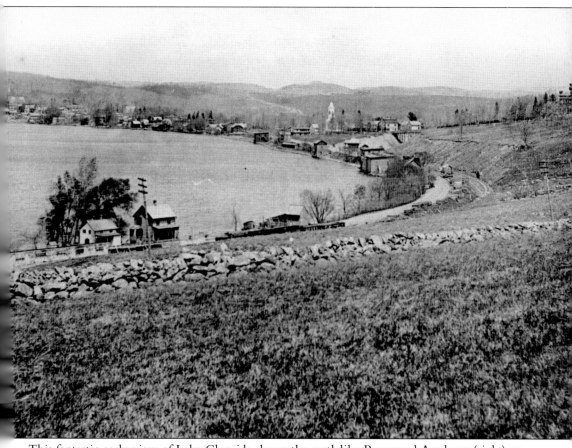

This fantastic early view of Lake Gleneida shows the castlelike Raymond Academy (right) on Seminary Hill Road and the original house along the eastern shore. The railroad tracks, now a bike path, run along the base of Seminary Hill. The white steeple (center) may be the early Giliard Presbyterian Church. The Mount Carmel Baptist Church steeple (left) can also be seen.

PLATE LXV.

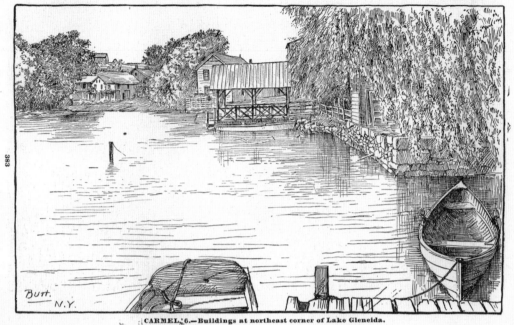

383

CARMEL, 6.—Buildings at northeast corner of Lake Gleneida.

A pen-and-ink sketch shows some of the houses and docks that lined Lake Gleneida before they were removed by the City of New York. The scene is identified as the northeast corner of the lake, and the drawing is signed by the artist "Burt."

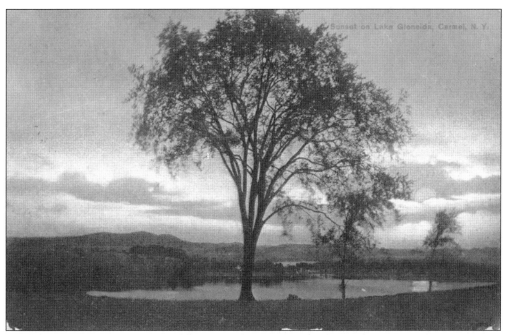

The sun sets behind a majestic elm on the shores of Lake Gleneida. Nearly all of these trees fell victim to Dutch elm disease. In Carmel, however, two disease-resistant varieties have been planted by the Putnam County Courthouse, replacing the ones that stood there in the 1940s.

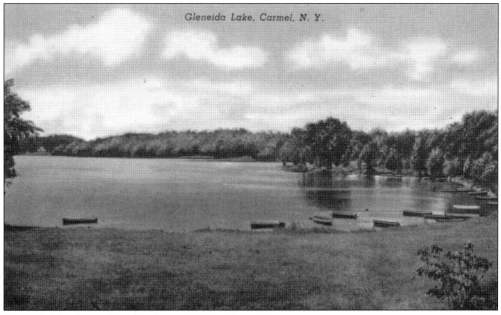

Many fishing boats line the shore of Lake Gleneida.

Pictured is the junction of Seminary Hill Road and Gleneida Avenue with the lake and some farmers' fields in the right distance.

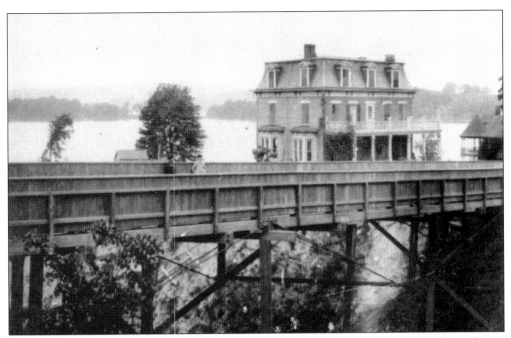

The trestle bridge of the Putnam Division of the New York Central Railroad stood near Lake Gleneida.

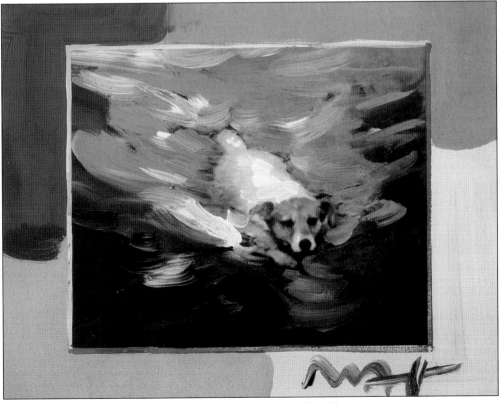

Jackie Ruckles is portrayed swimming in Lake Gleneida illegally.

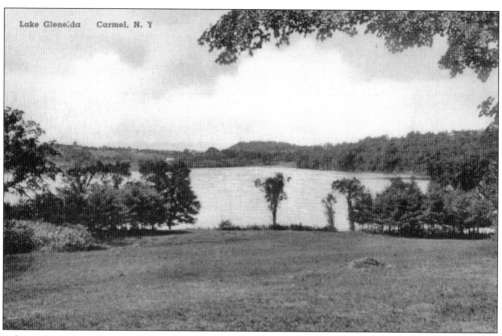

Lake Gleneida Carmel, N. Y.

A lone American elm stands on the shore in the center of this Lake Gleneida postcard.

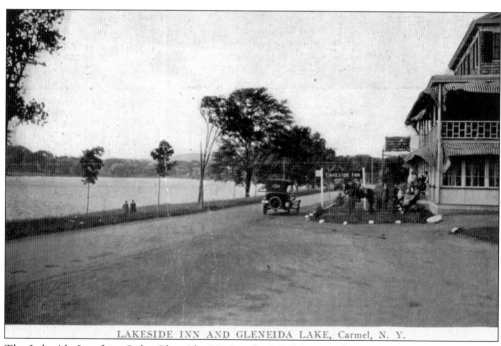

LAKESIDE INN AND GLENEIDA LAKE, Carmel, N. Y.

The Lakeside Inn faces Lake Gleneida. Notice the Model T Ford on the road and the horse in front of the inn. The transition from horse to automobile was underway.

82

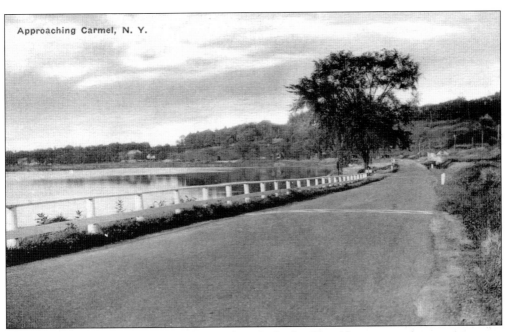

The road approaches Carmel from the south end of Lake Gleneida.

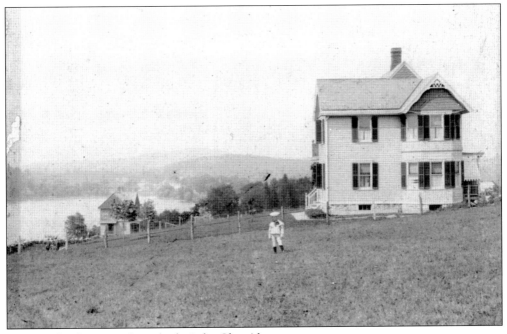

The Smalley homestead overlooks Lake Gleneida.

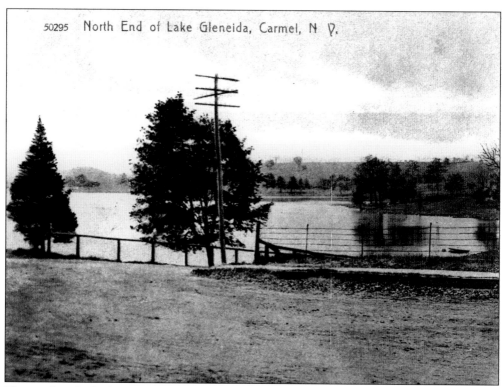

The north end of Lake Gleneida has fencing to keep stray cattle out of the drinking water. Note the old telegraph pole.

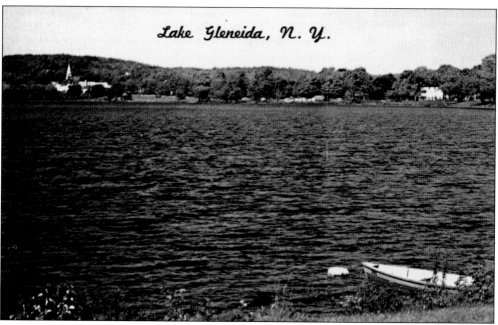

This shot of Lake Gleneida was taken in color in the 1960s. Fishing is still allowed on the lake, and the Mount Carmel Baptist Church still towers over the village.

Seven

New York City Reservoir System and Natural Beauty

The New York City Reservoir System is one of the greatest engineering feats of all time. The Croton and Delaware watersheds produce clean, fresh water to the eight million residents of New York City. The Croton watershed is located primarily in Putnam County where the Croton River was dammed, flooding the community's most valuable farmland but creating the beauty of the lakes that dot the town of Carmel.

The town of Carmel is also blessed with some of the most beautiful vistas, lakes, mountains, and streams in all of the Hudson Highlands. The natural beauty has given rise to the county slogan, "where the country begins."

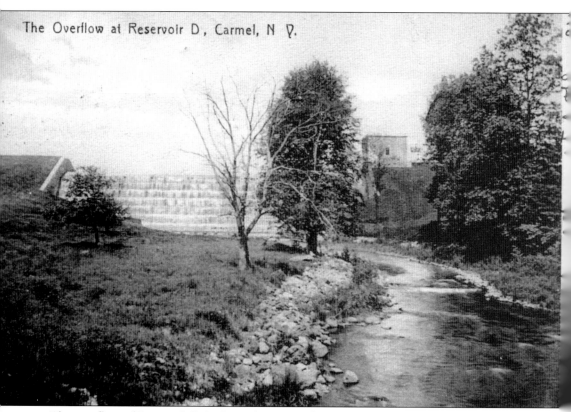

The overflow of Reservoir D in Carmel is pictured in 1906. These beautiful dams were created out of local granite.

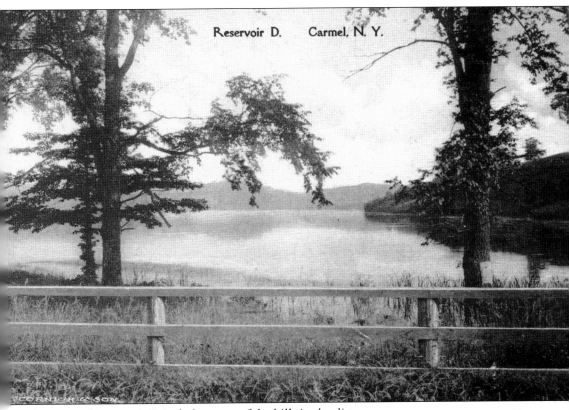

This view of Reservoir D includes some of the hills in the distance.

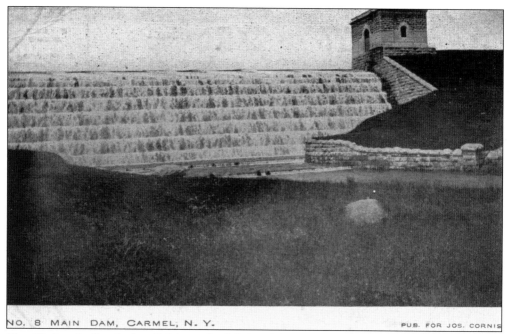

NO. 8 MAIN DAM, CARMEL, N. Y. PUB. FOR JOS. CORNIS

Identified as the "main dam," this was built behind the Belden House in Carmel. The notation indicates that the postcard was published "for Jos. Cornish."

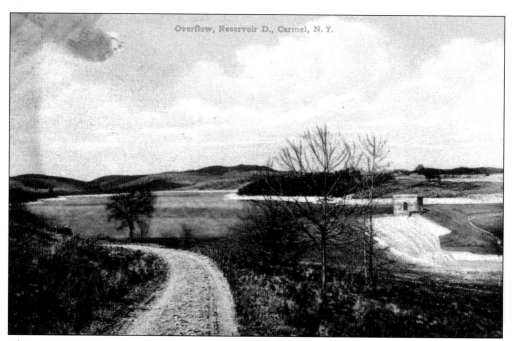

Overflow, Reservoir D., Carmel, N. Y.

This postcard offers a broad view of the overflow of Reservoir D.

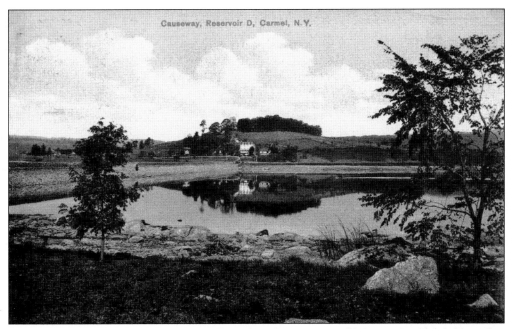

Causeway, Reservoir D, Carmel, N.Y.

The causeway crosses Reservoir D. Reflected in the water is Old Causeway Hotel, located at the opposite end of the Gipsy Trail Road intersection.

This contemporary view of Putnam County is courtesy of the New York City Department of Environmental Conservation.

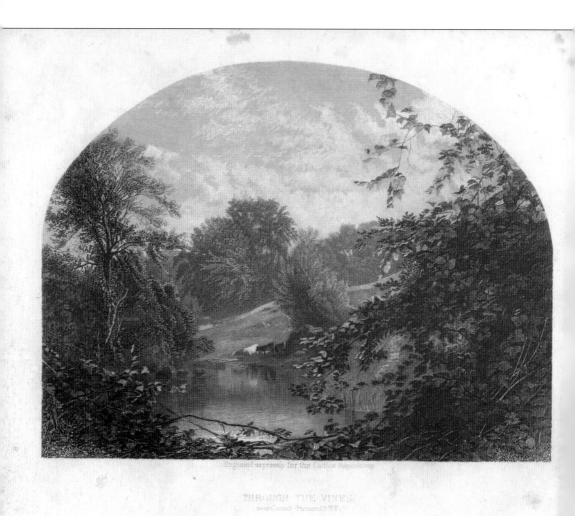

Engraved expressly for the Ladies Repository

THROUGH THE VINES.
(near Carmel - Putnam Co N.Y.)

This early engraving of a rural scene near Carmel is entitled *Through the Vines.* The view includes a pond with cows grazing on its shore. It was engraved "expressly for the Ladies Repository" by R. Hinshelwood from a painting by James M. Hart.

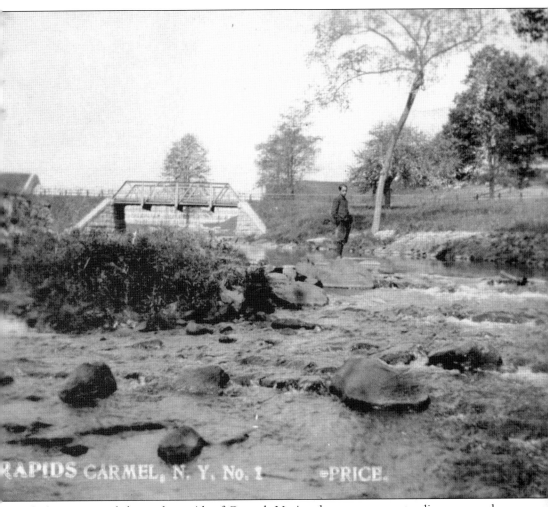

RAPIDS CARMEL, N. Y. No. 1 — PRICE.

A real-photo postcard shows the rapids of Carmel. Notice the young man standing on a rock out in the water with his hands in his pockets.

LAKE GILEAD, CARMEL, N.Y.

Another beautiful lake in Carmel is Lake Gilead.

Eight

HEROES

The county has at least three Revolutionary War heroes that figure in its history. The first is Gen. Israel Putnam, who defended the Hudson Highlands, including the town of Carmel, in the Revolutionary War. For this service, the county was named in his honor when it was set off from Duchess County in 1812.

The second hero of the Revolutionary War was Enoch Crosby, who was made famous by James Fennimore Cooper's novel *The Spy.* He is buried in the old Gilead burial grounds.

Last but certainly not least is the only female combat veteran of the Revolutionary War, Carmel's own Sybil Ludington. As a 16 year old, she rode to get the troops out to march under the command of her father, Col. Henry Ludington, to fight the British who were burning Danbury, Connecticut. Putnam County residents are proud of Sybil's heroism, which is shown by a bronze statue that stands on the shores of Lake Gleneida that was dedicated by the Daughters of the American Revolution.

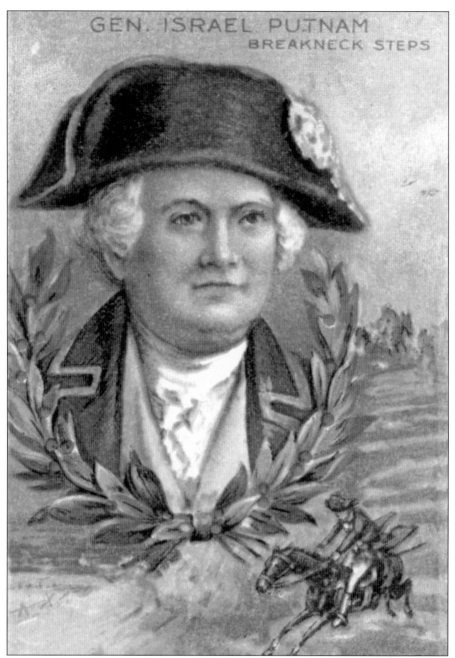

GEN. ISRAEL PUTNAM
BREAKNECK STEPS

A tobacco trading card shows Gen. Israel Putnam fleeing on horseback from the British. He is pictured going down the "Breakneck Steps" in Connecticut being pursued by the British. It was a close call, as the stunned British fired at Putnam and put a hole in his hat.

This painting by J. Wilkinson shows Putnam leaning against a cannon after he became a general. He defended the Hudson Highlands during the Revolutionary War.

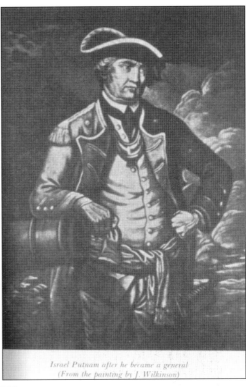

Israel Putnam after he became a general
(From the painting by J. Wilkinson)

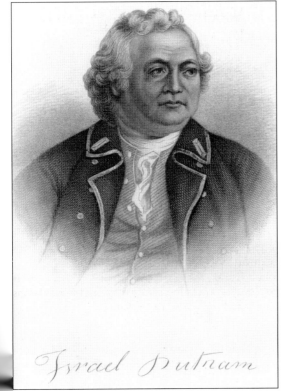

An older and heavier Putnam is portrayed here with a facsimile signature below.

95

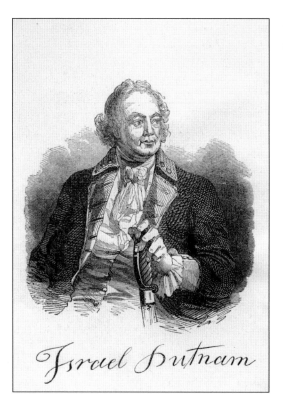

Israel Putnam

This portrait shows Gen. Israel Putnam in military uniform with his sword.

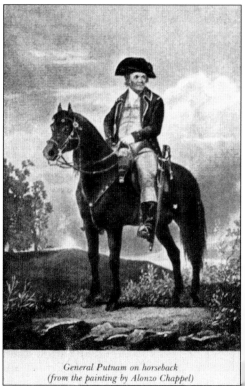

General Putnam on horseback
(from the painting by Alonzo Chappel)

The painting by Alonzo Chappel shows Putnam on horseback. The horse appears to be somewhat too small for the large general.

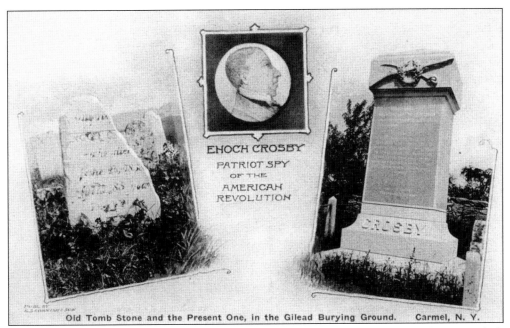

Enoch Crosby was a patriot spy during the Revolutionary War. This postcard shows Crosby's original tombstone and its replacement stone in the Gilead burial grounds. Crosby was so famous that his original headstone was chipped away by souvenir seekers.

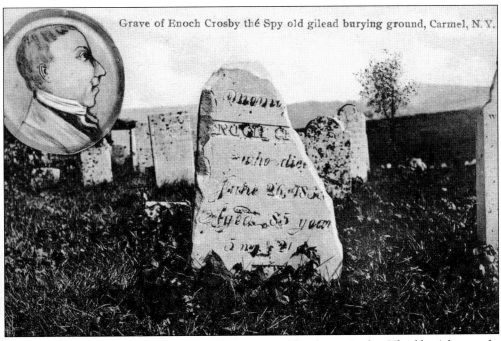

Crosby lived to age 85. He is pictured with his original headstone in the Gilead burial grounds.

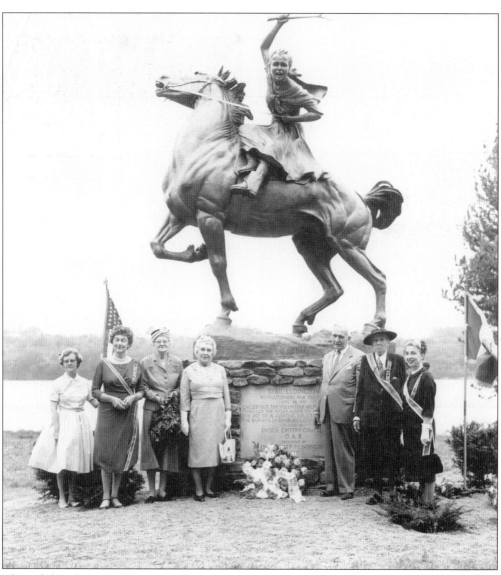

The Sybil Ludington statue is dedicated in a ceremony on the shore of Lake Gleneida. The 16-year-old Revolutionary War heroine rode to alert the military of the burning of Danbury, Connecticut, by the British on April 26, 1777. The local chapter of the Daughters of the American Revolution conducted the dedication ceremony.

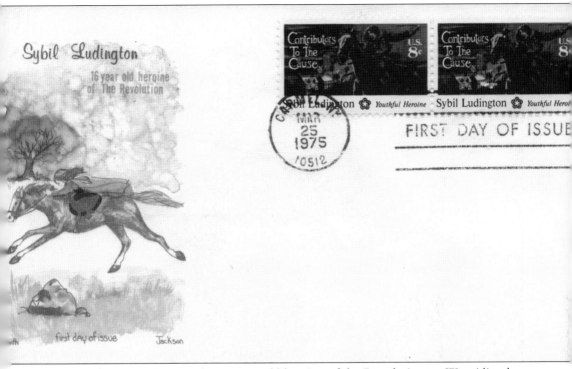

A first-day-of-issue card shows the 16-year-old heroine of the Revolutionary War riding her horse, Star.

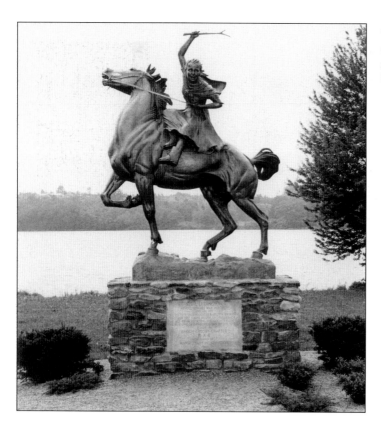

This photograph is of the Sybil Ludington statue at the time of its dedication.

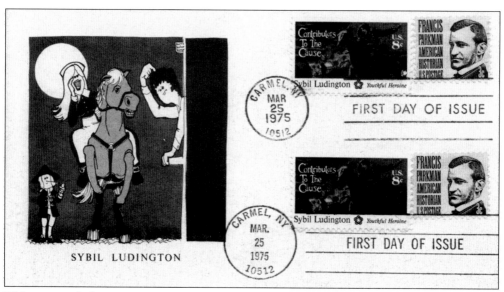

This postcard shows a cartoon version of Ludington calling out the troops during the Revolutionary War.

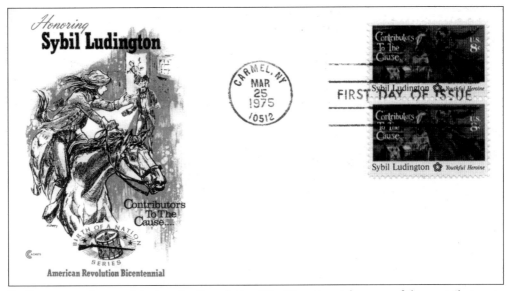

Ludington was honored during the Revolution War Bicentennial as one of the contributors to the patriot cause.

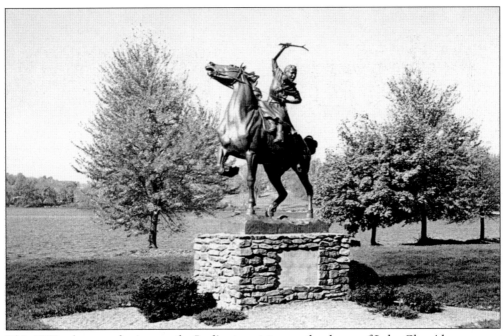

This 1960s photograph pictures the Ludington statue on the shores of Lake Gleneida.

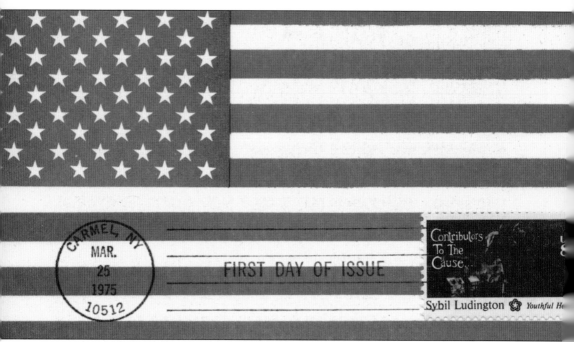

This postcard commemorates the first day of issue of the Sybil Ludington 8¢ stamp.

As a contributor to the Revolutionary War cause, Ludington was honored with the stamp in 1975. Pictured is a full print block of the stamp.

Here is a first–day–of–issue contribution to the cause commemoration envelope.

Souvenir Wood Post Card

SSSSSSSSSSSSSSSSSSSS

First Day Of Issue - Sybil Ludington 8c Stamp

On April 26, 1977 British troops under the command of General Tryon reached Danbury, Connecticut. Patriot messengers rode out to the surrounding countryside to tell of the British attack and summon the militia. One such messenger reached the home of Col. Henry Ludington who resided in Fredricksburg Precinct (now part of Dutchess and Putnam Counties) in New York. Since Col. Ludington's militia were all at home a messenger was needed to summon them. Sybil Ludington, the colonel's 16 year old daughter, volunteered for the task.

She rode through the night calling out the militia and by morning all the troops had gathered and set out for Danbury. Joined by the forces of three other regiments they drove the British from Danbury and back to their ships on Long Island Sound.

CROTON RIVER NUMISMATIC SOCIETY

The Croton River Numismatic Society created souvenir wooden postcards for the first day of issue of Sybil Ludington 8¢ stamp.

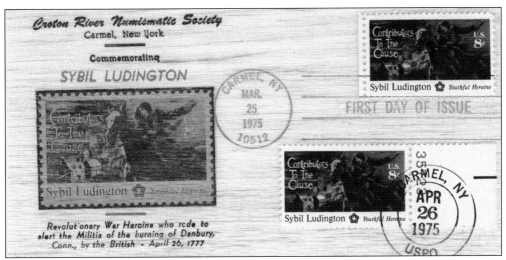

A wooden postcard honors the Revolutionary War heroine. At age 16, Ludington rode her horse to call out the troops, as the British were burning Danbury, Connecticut, on April 26, 1777.

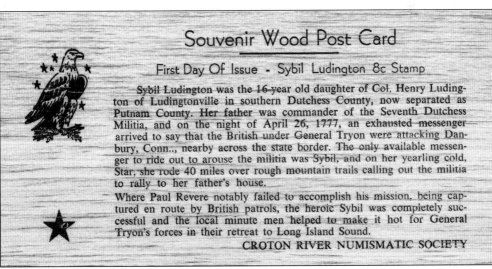

A souvenir wooden postcard relates the story of Ludington's daring ride. Whereas Paul Revere failed on his ride, Ludington was successful on hers.

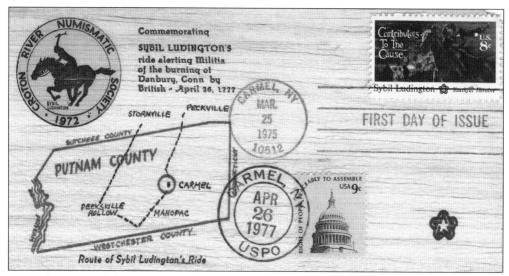

A wooden postcard depicts a map of Sybil Ludington's famous ride, demonstrating that she rode through the hamlet of Carmel.

Souvenir Wood Post Card

First Day Of Issue - Sybil Ludington 8c Stamp

The eight-cent Sybil Ludington stamp pictured in the cachet is one of four honoring some of the lesser known "Contributors to the Cause" in the Revolution. It was designed by Neil Boyle and had its first day at Carmel, N.Y. Sybil's heroic night ride to call out the Dutchess County Militia earned her the gift of the mount she rode, the colt named Star, from her father, Col. Henry Ludington, a veteran of the French and Indian War whose commander in that war was the same General William Tryon whose attack on nearby Danbury, Conn., was the occasion of the ride. Sybil was the eldest of 12 children and married Edward Ogden, a Catskill lawyer, and had six children of her own. She died at the age of 77 and is buried at Patterson, N.Y.

CROTON RIVER NUMISMATIC SOCIETY

This wooden postcard recounts the details of Ludington's personal life.

Nine

SPAIN
CORNERSTONE PARK

One of the recent successes in Carmel has been the transformation of an abandoned gas station and automobile repair shop into a cornerstone park, a monument for the Putnam County victims of September 11, 2001, and a welcome and meeting center. The idea for reviving the corner of Gleneida Avenue and Fair Street came about in 1999, and a public-private partnership brought the idea to fruition: local businessman John Spain, who donated the property to be named in honor of his late sister, Laura Spain, a victim of cancer; Bob Bondi, Putnam county executive; Don Smith, then deputy county executive; Frank Del Campo, latter deputy county executive; the Putnam County legislature; the State of New York, represented by Sen. Vincent Leibell; and the Office of Parks, Recreation, and Historic Preservation. Highway commissioner Harold Gary and assistant Emma Kounine masterminded the transformation. The park was designed by Brewster architect Jim Nixon. Families of the victims of the September 11, 2001, terrorist attack chose to put their memorial in Cornerstone Park. As Sheriff Smith said at the dedication ceremony, the memorial made the park "hallowed ground."

In a larger context, Carmel's Spain Cornerstone Park is a model example of what can be done with closed gas station sites, which number close to 2,000 throughout the state of New York. Cornerstone Parks of New York, a new nonprofit organization founded by Allison Whipple Rockefeller, is working with state and county government, service station owners, and community and nonprofit groups to transform downtown eyesores into centers for community use.

Each park will be used in ways expressly designed and designated by its community, and as part of a statewide network, will join other cornerstone parks in offering programs that celebrate and document New York's people, culture, and history.

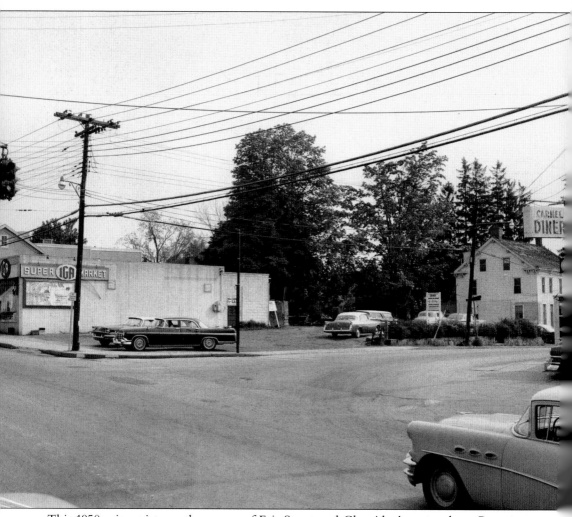

This 1950s view pictures the corner of Fair Street and Gleneida Avenue where Cornerstone Park is today.

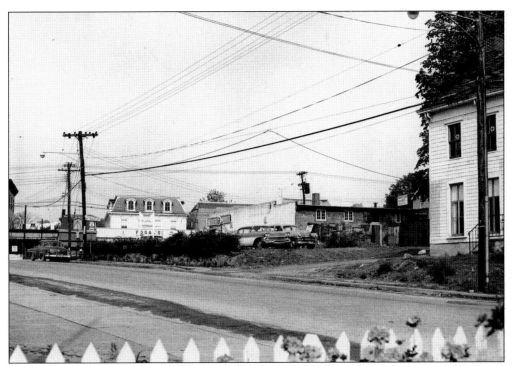

Here is another view from the 1950s. Today the electric wires and Fogal's Five-and-Ten-Cent Store are gone.

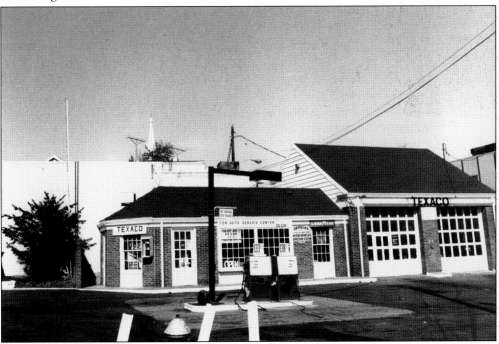

Spain Oil Corporation owned this Texaco gas station in 1982. In the following decade, businessman John Spain donated the property for the new park, to be named in honor of his late sister, Laura Spain.

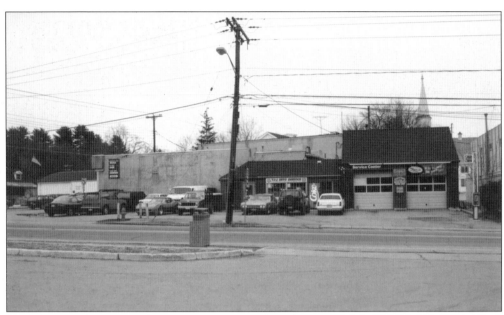

An automobile repair shop occupied the future site of Cornerstone Park in the late 1990s.

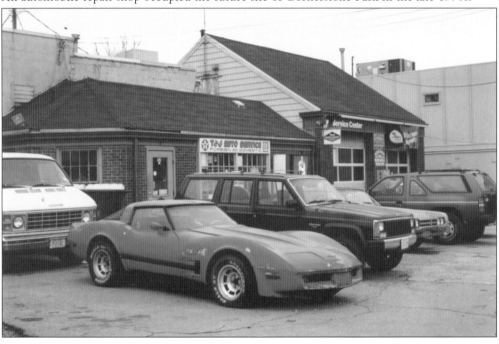

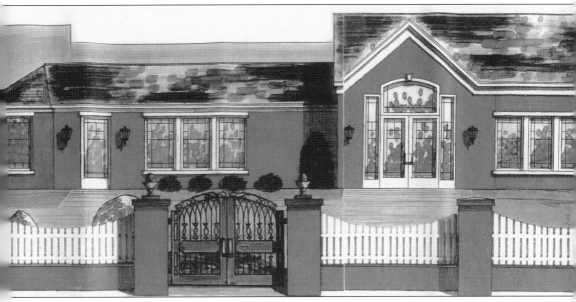

Shown is an artist's rendering of the original plan to convert the gas station–repair shop into a welcome center.

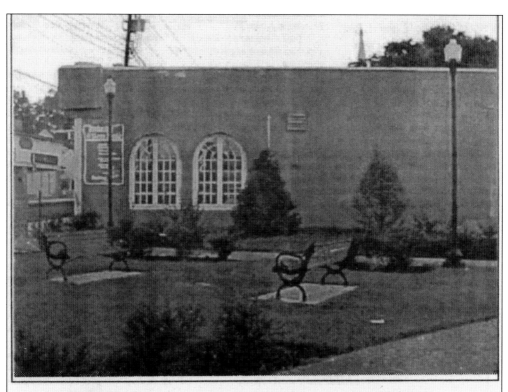

Cornerstone Park Nears Completion

A small park in the center of Carmel with a small building that will have a visitors center and museum has become a reality.

A ribbon cutting ceremony will be held Friday, September 17th at 12 noon.

The park and refurbished building replaces a gas station that had seen better days

The cost of the project amounted to $430,000. In 2002 the county reserved $150,000 grant from the state Office of Parks, Recreation and Historic Preservation.

Fourmen Construction of Peekskill was awarded the contract for $334,000 and the rest of the money went to defray additional costs that included using Putnam Highway Department workers to bring the project in at the allotted cost.

Construction began early this year. Workers topped the concrete with hardwood flooring, replaced doors with arch-topped windows, and constructed an 8-by-12-foot vestibule that serves as an entryway to the structure. Pathways run through the 48-by115-foot parcel, that has four benches and plantings.

A monument honoring the eight Putnam residents who died in the Sept. 11, 2001, terrorist attack on the World Trade Center is at the south-western corner.

The land owned by Spain Oil was donated to Preserve Putnam County Foundation who in turn leases it to the county for a small fee.

The completion of the park comes at a time when other improvements to the hamlet are being completed as well. The sidewalks are finished and the Main Street has been widened and blacktopped from Reed Library to Horsepound Road.

One of the final parts of the revitalization is the connection of all houses and businesses to the underground electrical system and the removal of the poles and overhead wires.

This newspaper article tells the story as "Cornerstone Park nears completion." A ribbon–cutting ceremony was set for noon on Friday, September 17, 2004. The park, a 48-by-115-foot parcel, was developed at a cost of $430,000.

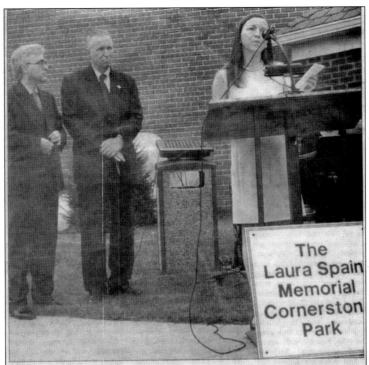

Allison Whipple-Rockefeller addresses last week's dedication of the Laura Spain Memorial Park in Carmel while her brother, George Whipple, (left) and Deputy County Executive Frank DelCampo listen. (Photo by Eric Gross)

Carmel Cornerstone Park officially dedicated

By Eric Gross
Staff Reporter

HAMLET OF CARMEL— The culmination of a public-private partnership was reached Friday when the new Laura Spain Cornerstone Park was dedicated in downtown Carmel before an audience of some 75 well-wishers.

Members of the Spain family donated the land along Fair Street at Gleneida Avenue to the Preserve Putnam County foundation. Under the direction of the group's executive director George Whipple, who worked with County Executive

Robert Bondi and members of county government, the former service station that stood on the corner was converted into a centerpiece for the downtown revitalization.

Whipple praised Commissioner of Highways and Facilities Harold Gary and his assistant Emma Kounine for their extraordinary work. "Converting an ugly gas station into a conference center is not easy. It takes a visionary like our architect to make this a beautiful and usable building," he said.

Whipple also commended State Sen. Vincent Leibell for his efforts by "bringing home the bacon," and the Putnam Legislature for endorsing my "wacky idea that I had drawn on the back of an envelope. They funded it and supported the project through good times and bad times."

Allison Whipple-Rockefeller, a park commis-

sioner, told the audience that New York had a "long tradition of preserving open space. From the earliest charter of the six-million acre Adirondack State Park in 1882 to the adaptive reuse of this one-third of an acre in the crossroads of our little community, the Laura Spain Park represents the creative energy of the partnerships New Yorkers create when they try to make a better community."

Putnam Deputy County Executive and former Carmel Supervisor Frank DelCampo called the park a "perfect marriage. A dilapidated service station owned by the Spain family was donated to Whipple's organization. The Carmel-Mahopac Revitalization-Restoration organization received additional funding through the Greenway Council. Putnam introduced matching dollars and the result is this magnificent facility for every resident of our county to enjoy," he said.

The newspaper headline reads, "Carmel Cornerstone Park officially dedicated." Pictured, from left to right, are Preserve Putnam County founder George Carroll Whipple III, deputy county executive Frank Del Campo, and park commissioner Allison Whipple Rockefeller. The sign that is pictured bears the official name of the park: the Laura Spain Memorial Cornerstone Park.

By Eric Gross
Staff Reporter

CARMEL – The weather outside was positively frightful yet 300 brave souls gathered beneath a large canopy at Putnam's new Cornerstone Park in downtown Carmel to officially dedicate the Putnam Heroes Memorial.

Saturday's ceremony recognized not only the eight residents of Putnam who perished on September 11, 2001, but the scores of others who supported the rescue effort in Manhattan following the terrorist attacks on the World Trade Center.

Families of the special eight who made the supreme sacrifice received ovations when the names of their loved ones were announced. They included firefighters Christopher Blackwell of Putnam Lake, George Cain of Patterson, Daniel Harlin of Kent, Thomas Kuveikis of Kent and Robert Minara of Carmel.

Also receiving an ovation were the families of New York City Police Officer Stephen Driscoll of Lake Carmel, Fiduciary Trust International employee and floor fire marshal David Fodor of Garrison and George Paris of Lake Carmel, an employee of Cantor Fitzgerald.

The memorial was spearheaded by retired New York City Police Sgt. James O'Neill and Lt. Denis Hanrahan of the FDNY.

Mr. O'Neill recalled "immediately after the impact of the tragedy hit home, Putnam residents like those across America were determined to do something. People rolled up their sleeves and donated blood. Others traveled to New York to help at Ground Zero.

Men, women and children donated food, medical supplies and other necessities needed by the brave rescue workers."

Mr. O'Neill called the loss of life to Putnam County families "horrific. The Putnam Heroes Memorial will now serve as a focal point for all of Putnam County."

As State Senator Vincent Leibell put it: "Young and old alike are here to remember our loss. Out of this sadness, we have been brought together. As we pass this park in the future we will recall the events of 9-11 but we will also remember that the horror in lower Manhattan was the greatest rescue effort that the world has ever known. The lives were not lost in vain. They were given for others," he said.

Senator Leibell said while "we mourn our loss, we are gratified that we live in a nation where such brave men and women give their all for others."

Following a wreath laying ceremony, Brad Little, who starred in the "Phantom of the Opera," sang a moving rendition of "The Music of the Night," before [...] by a chorus which led [...] gation in "God Bless [...]

There wasn't a dr[...] audience.

Donations are still [...] help offset the cost o[...] rial. Anyone wishin[...] may send a tax-ded[...] to the Putnam Heroes [...] care of Patrick Mc[...] 2435 Route 6, B[...] 10509.

Checks may also [...] to the Putnam Hero[...] Box 6, Carmel, NY [...]

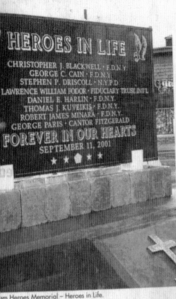

HEROES IN LIFE

CHRISTOPHER J. BLACKWELL · F.D.N.Y.
GEORGE C. CAIN · F.D.N.Y.
STEPHEN P. DRISCOLL · N.Y.P.D.
LAWRENCE WILLIAM FODOR · FIDUCIARY TRUST INT'L
DANIEL E. HARLIN · F.D.N.Y.
THOMAS J. KUVEIKIS · F.D.N.Y.
ROBERT JAMES MINARA · F.D.N.Y.
GEORGE PARIS · CANTOR FITZGERALD

FOREVER IN OUR HEARTS
SEPTEMBER 11, 2001
★ ★ ★ ★ ★

...am Heroes Memorial ~ Heroes in Life.

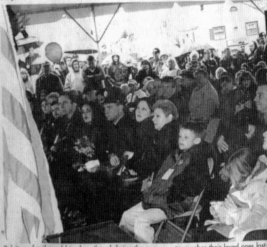

Relatives, family and friends gathered during the ceremony to remeber their loved ones lost [...] 2001. Christopher Harlin (front row holding flag) next to sister, Katie (right) and mom Debbi[...] remember their father and husband, Danny Harlin. (Photos by Eric Gross)

The Putnam Heroes Memorial, erected on Cornerstone Park's southwest corner, was dedicated to the eight Putnam County residents who died as a result of the September 11, 2001, terrorist attack on the World Trade Center. The eight were Christopher J. Blackwell of Putnam Lake, George C. Cain of Patterson, Stephen P. Driscoll of Lake Carmel, Lawrence William Fodor of Garrison, Daniel E. Harlin of Kent, Thomas J. Kuveikis of Kent, Robert James Minara of Carmel, and George Paris of Lake Carmel.

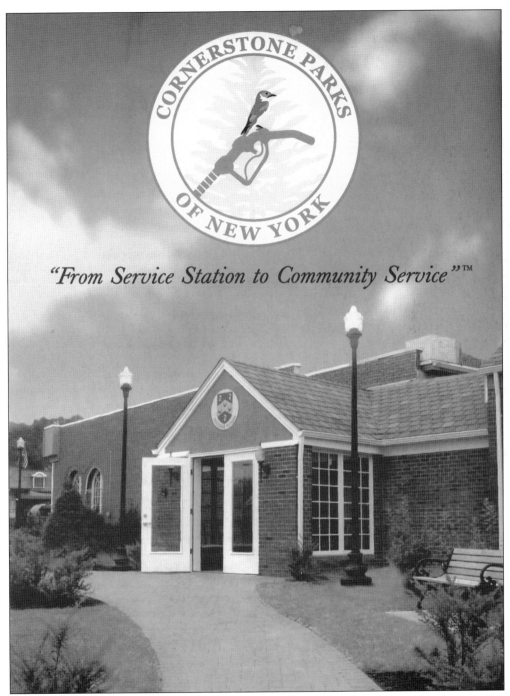

With its slogan, "From service station to community service," the nonprofit organization Cornerstone Parks of New York is working to create a statewide network of small parks and community centers out of abandoned downtown gas stations. The organization was founded by Allison Whipple Rockefeller, and Spain Cornerstone Park in Carmel serves as the model. Although each community will have its own design and use for its park, all will present common programs on the state's history and culture.

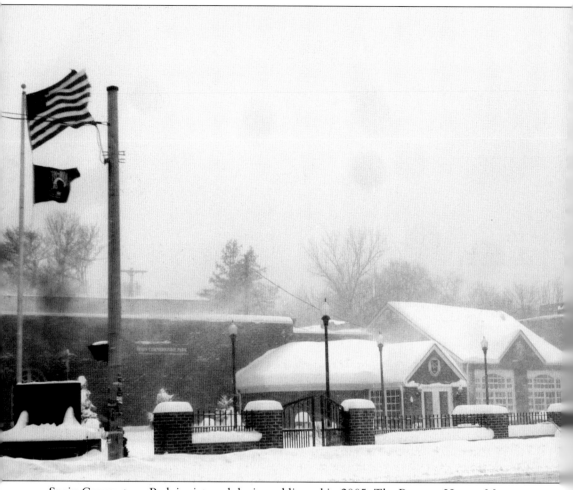

Spain Cornerstone Park is pictured during a blizzard in 2005. The Putnam Heroes Monument stands by the flagpole. The United States and POW-MIA flags fly high in the wind.

Ten

THE BELDEN HOUSE AND
THE STONE CHAMBERS

The Belden House, built in 1760 by Thomas Belden, is perhaps the most important Carpenter Gothic structure in the Hudson River Valley and perhaps in the entire United States. Located in Carmel, the site has been occupied for 3,000 years (American Indians camped here for generations). It was the site of the home of the original caretaker for the Philipse family who owned all of Putnam County. This historic structure was altered over time, with its last renovation being in the period of prosperity that followed the opening up of the railroad into Putnam County, after the Civil War, which gave local access to the New York markets.

The residence is an exquisite example of the Gothic Revival architectural style. The house, which is on reservoir land, has long been owned by the City of New York. Recently the city committed to restore it. It is important to note that the highly decorative exterior is matched by the original interior, with fancy woodwork, high-relief plasterwork, and marble fireplace surrounds. Both the exterior and interior of this building need to be saved for future generations.

The stone chambers of Putnam County number over 100 and are shrouded in mystery and controversy. Some say that these were Colonial root cellars used to store and chill root crops over the winter. Some older Putnam County residents swear that their fathers or grandfathers built one of the stone chambers. Many early houses have no stone chambers, however, and many stone chambers are not near any early house sites.

Other people say that the Druids came to Putnam County searching for minerals that can be found in the rocky mountains of the Highlands and that they built these stone chambers as religious structures long before Columbus's time. Proponents of this theory note that the stone chambers face either the summer or the winter solstice. Modern-day Druids hold celebratory ceremonies in the stone chambers on the sunrise of the winter solstice. Whatever the true history of the stone chambers, there is no question that these unique structures, which exist in greater numbers in Putnam County than anywhere else on earth, should be preserved for future generations.

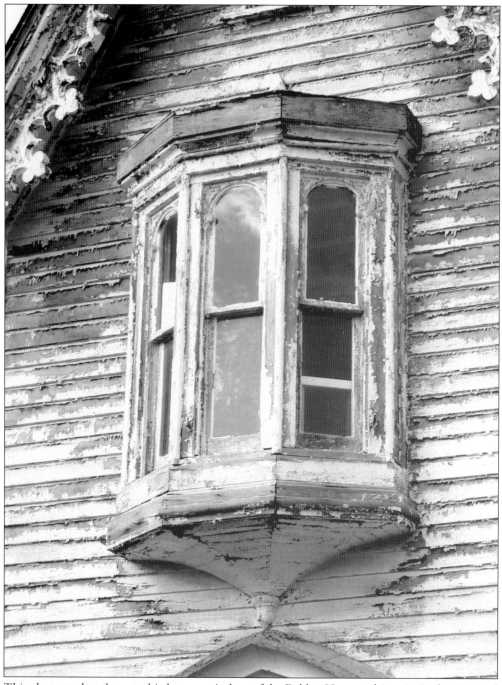

This close-up shot shows a third-story window of the Belden House, a historic Gothic Revival structure located in Carmel and owned by the City of New York.

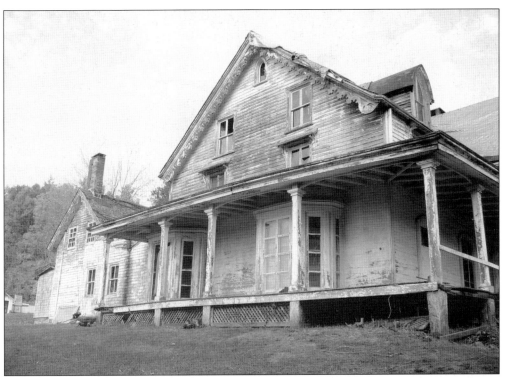

Built in 1760 by Thomas Belden, the Belden House is an important example of the Carpenter Gothic architectural style. This recent view shows the side of the Belden House.

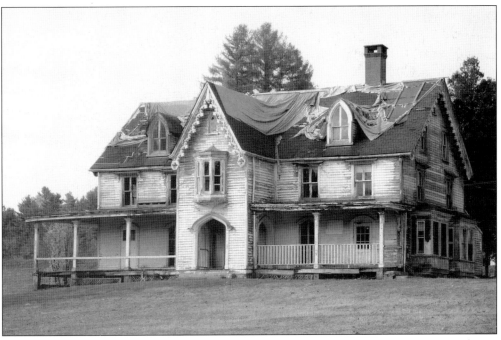

Another recent shot of the Belden House shows the roof temporarily covered. The City of New York plans to restore the building.

A horse and cart are pictured near the Belden House around the time of the Civil War.

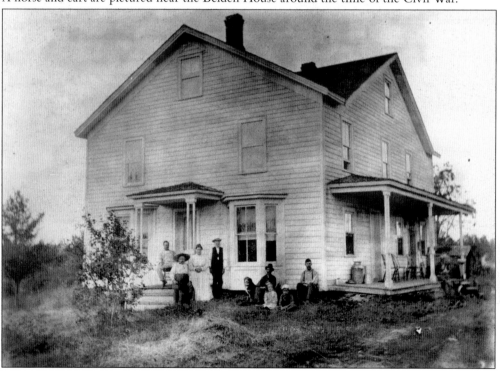

Eight people and one dog pose in front of the Belden House, and one person sits on the side porch, during the 1860s.

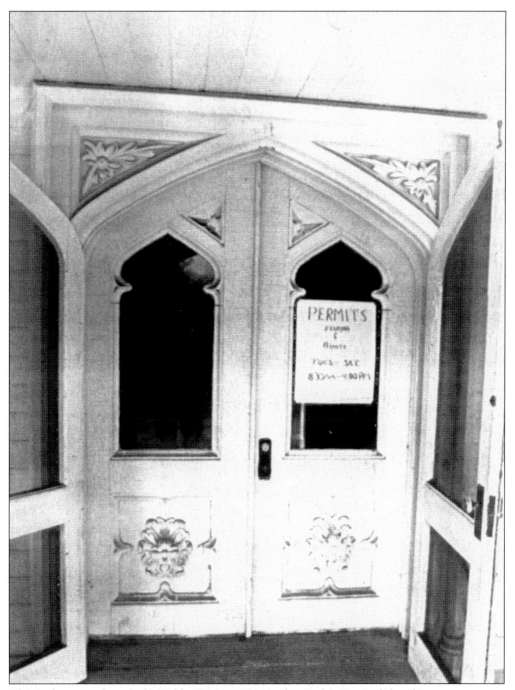

This is the entry door at the Belden House. Notice the Gothic Revival detail.

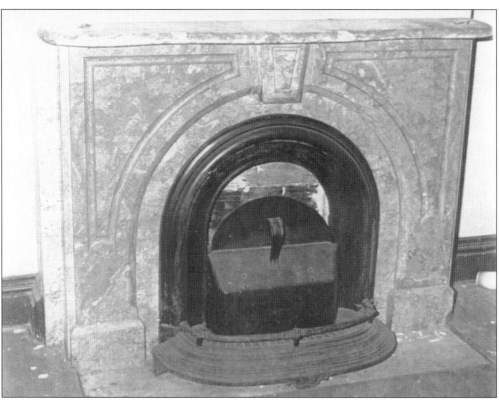

The fireplace in the first-floor parlor (above) has a marble surround. Black marble surrounds another Belden House fireplace (below).

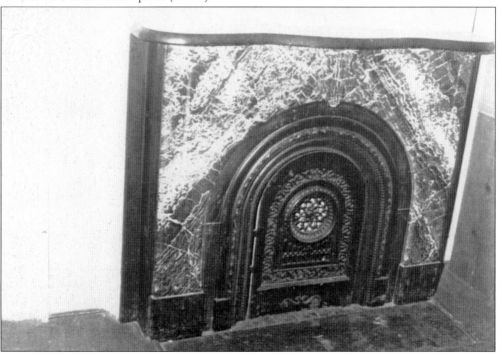

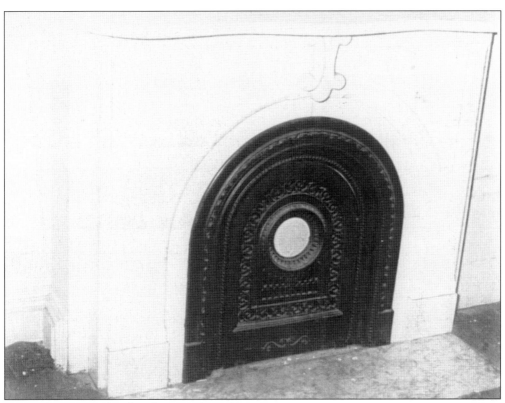

Pictured are two other fireplaces in the Belden House.

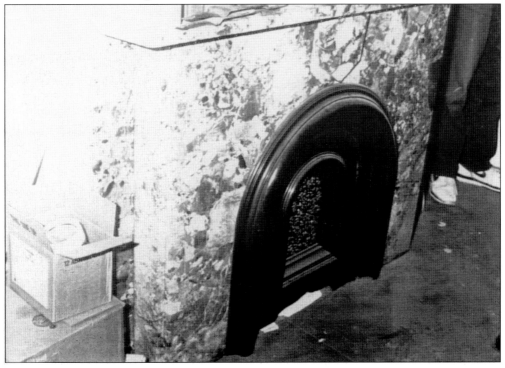

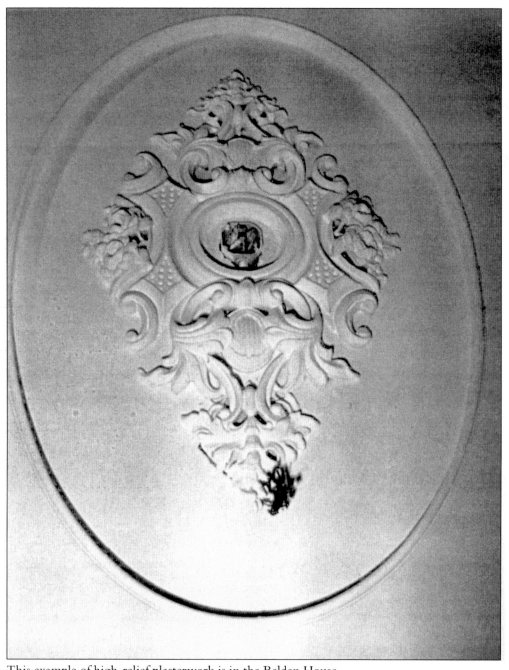

This example of high-relief plasterwork is in the Belden House.

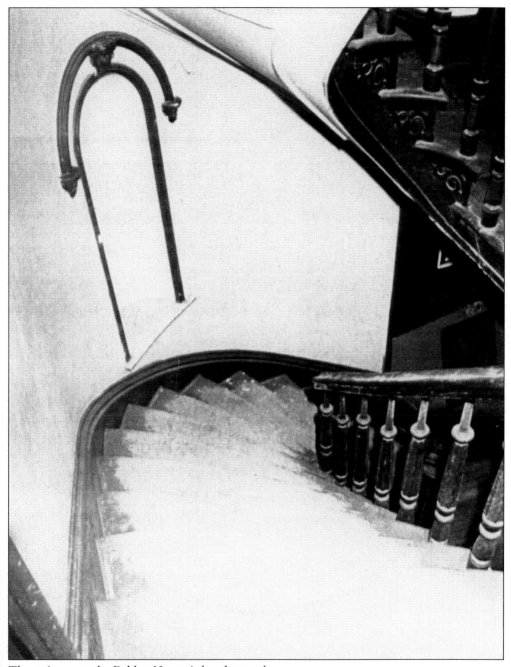

The stairway at the Belden House is hand carved.

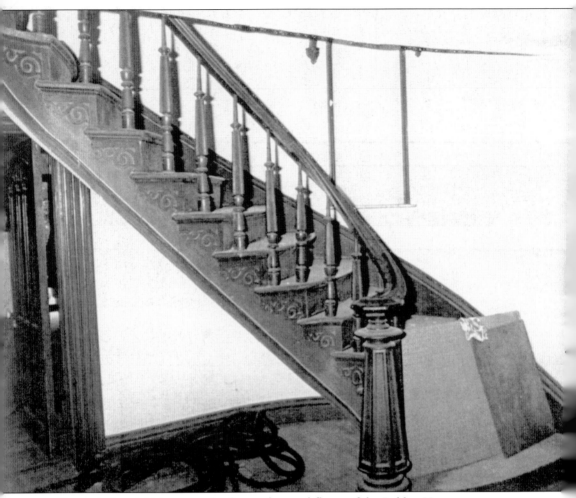

Shown is the niche between the first and second floors of the Belden House.

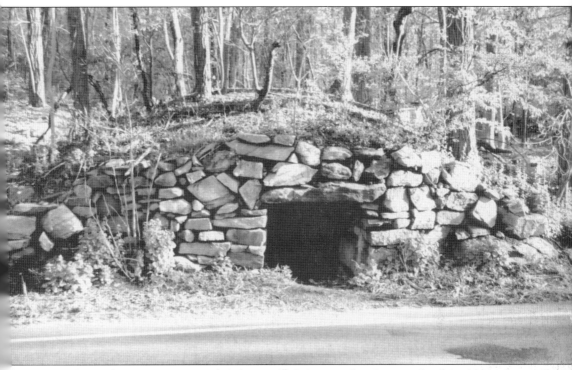

Putnam County has over 100 stone chambers, which is more than in any other location in the world. The stone cellars have existed for centuries, yet their purpose and use is still a subject of debate. Some people say they were created in Colonial days as root cellars. Others say they were built as religious structures by the Druids. Pictured is a fine example of one of Putnam County's many stone cellars.

ACROSS AMERICA, PEOPLE ARE DISCOVERING SOMETHING WONDERFUL. *THEIR HERITAGE.*

Arcadia Publishing is the leading local history publisher in the United States. With more than 3,000 titles in print and hundreds of new titles released every year, Arcadia has extensive specialized experience chronicling the history of communities and celebrating America's hidden stories, bringing to life the people, places, and events from the past. To discover the history of other communities across the nation, please visit:

www.arcadiapublishing.com

Customized search tools allow you to find regional history books about the town where you grew up, the cities where your friends and family live, the town where your parents met, or even that retirement spot you've been dreaming about.